WOODCUT

WOODCUT

WOODCUT

ep-by-Step Lessons in Designing, Cutting, and Printing the Woodblock

David L. Oravez

WATSON-GUPTILL PUBLICATIONS / NEW YORK

A special thanks to the following individuals and museums for their assistance and contributions to this book. Thanks to Howard Huff and Brent Smith for their superb photography work. For their assistance I thank the following individuals: Orvis Burmaster, Dr. Felix Heap, Darryl Huskey, Dr. George Jocums, Alfred J. Kober, and Candace Raney of Watson-Guptill. For their print contributions I thank Laura Hibbs, Cheri Mensching, Dana Merril, George F. Roberts, and Susan Stingley. I am indebted to the following museums for their cooperation and photographic contributions: The British Library, London; The British Museum, London; The Metropolitan Museum of Art, New York; The Museum of Modern Art, New York; The United States Playing Card Company Museum, Cincinnati.

Text set in 12 pt. Janson Text
Design by Don Raney Archigraphics

Copyright © 1992 by David L. Oravez

First published in 1992 by Watson-Guptill Publications,
a division of BPI Communications, Inc.,
1515 Broadway, New York, N.Y. 10036

Library of Congress Cataloging-in-Publication Data

Oravez, David L.
 Woodcut : step-by-step lessons in designing, cutting, and printing
the woodblock / David L. Oravez.
 P. cm.
 Includes bibliographical references and index.
 ISBN 0-8230-5851-4
 1. Wood engraving—Handbook, manuals, etc. I. Title.
NE1223.07 1992
761'.2—dc20 91-31850
 JUL 2 9 1994 CIP

Distributed in the United Kingdom by Phaidon Press, Ltd.

Distributed in Europe, the Far East, Southeast and Central Asia, and South America by RotoVision S.A., 9 Route Suisse, CH-1295 Mies, Switzerland.

Manufactured in the U.S.A.

First printing, 1992

1 2 3 4 5 6 7 8 9 10/97 96 95 94 93 92

To Billie Booth Oravez

CONTENTS

INTRODUCTION

Printmaking allows the artist to reach a wide audience by producing multiples of the same image. One of the least complex and most economical methods of printmaking is woodcut.

The method of woodcut printing described here in this guide emphasizes a traditional approach designed to give the novice printmaker a foundation upon which to build. Emphasis has been placed on black-and-white design, with step-by-step instructions to be followed for execution.

I have attempted to supply as much information as possible to insure a reasonable amount of success in your finished product. The book is arranged in the order of the steps one would take in creating a woodcut, from planning a design to matting and framing the completed print. If this is your initial introduction to the medium, and if you are not receiving any additional guidance from an instructor, it is important to follow the instructions precisely. Of equal importance is the discussion of materials in chapter 3. Regardless of how superb an artist's concept is, a print is destined for failure if incorrect or inferior materials are used in the woodcut.

Steps in the production of a woodcut can be divided into three distinct categories: conceiving and drawing the image, cutting the block, and printing the block. Few beginners instantly master all three, so do not become discouraged if you have some difficulty in one or more of these areas. Your print may not come out exactly as you intended it; printmaking can be full of surprises. Enjoy your successes. Learn from your failures. There is no substitute for experience.

It is in the area of conception and drawing that experience plays an important role. Being unfamiliar with the possibilities and limits of the medium, the novice sometimes renders a design that is not very well suited to execution in wood. But take heart: this misfortune seldom happens twice.

Despite any limitations the medium may have you will find that combinations of line, shape, form, textures, and techniques afford limitless possibilities. Whether your work is meticulous and exacting or bold and spontaneous, woodcut can be an exciting medium.

A word should be said about the difference between the woodcut and the wood engraving (see the following two pages). A woodcut is produced by the use of scooped tools called gouges to cut into plank-grain wood, which is wood cut with the grain of the tree; a wood engraving is made with solid tools that cut into end-grain wood, which is wood cut across the grain of a tree. Such exceedingly hard woods as boxwood or apple are used for wood engraving. What can be confusing are terms used in both media: Rectangular sections cut from either plank-grain wood or end-grain wood are generically referred to as *woodblocks*. Both woodcut and wood engraving are classified as relief printing—the term *relief* meaning "raised."

There is a basic difference in result: A woodcut is usually bolder and less detailed than a wood engraving. The woodcutter should note this distinction and not try to duplicate techniques best used by the engraver. Much more practice and experience is required for wood engraving. Further information on wood engraving can be obtained by consulting books on the subject recommended in the bibliography.

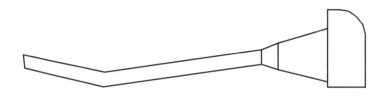

WOODCUT

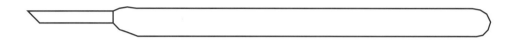

Knife

V-Gouge

U-Gouge

C-Gouge

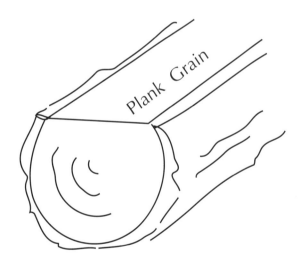
Plank Grain

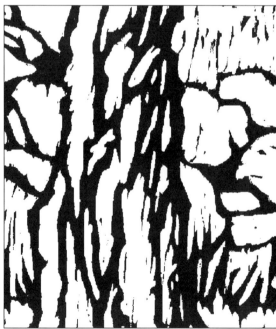

Detail from a woodcut by Laura Hibb

A woodcut is made by cutting into plank-grain or side-grain wood with scooped tools. The two most popular cutting-tool styles are shown at the top. Directly below them are the most common types of cutting tips.

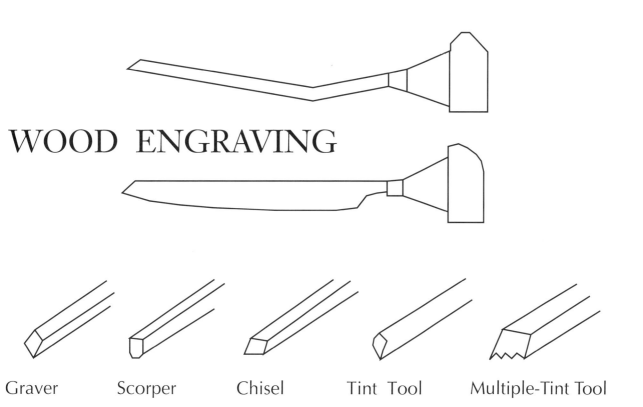

WOOD ENGRAVING

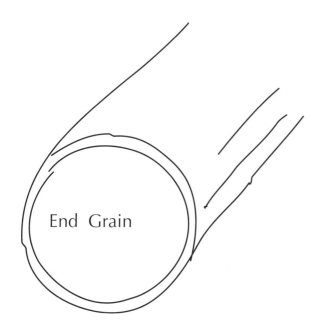

Graver Scorper Chisel Tint Tool Multiple-Tint Tool

End Grain

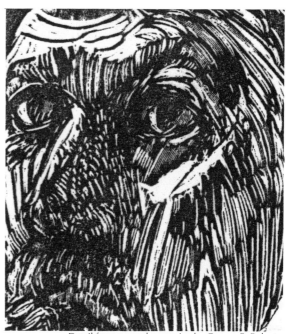

Detail from a wood engraving by George F. Roberts

wood engraving is made by cutting into end-grain
ood with solid tools. Two styles of wood engraving
ols are shown at top. Directly below them are
opular types of cutting tips.

THE WOODCUT

TRADITION

Woodcut printing originated in China, and much of its development can be credited to the invention of paper by the Chinese c. A.D. 105. Unfortunately, little is known about the history and techniques of Chinese woodcut. It is believed that woodcut was an outgrowth of other types of relief products such as seals. Seals are small stamps used to sign and seal official documents and letters. Seals are often made of wood or clay, and have designs or letters carved into them. The designs are transferred to wax or paper by pressing the stamp to the wax or paper.

The earliest known example of woodcut on paper is the Diamond Sutra of A.D. 868. Its intricate and skillful design indicates that the Chinese mastered the art of woodcut long before this manuscript was produced. During the eleventh century the Chinese developed the first movable type made from individual pieces of clay. But because the Chinese language contains hundreds of characters, it was more practical to carve them directly into the woodblocks than to set them individually.

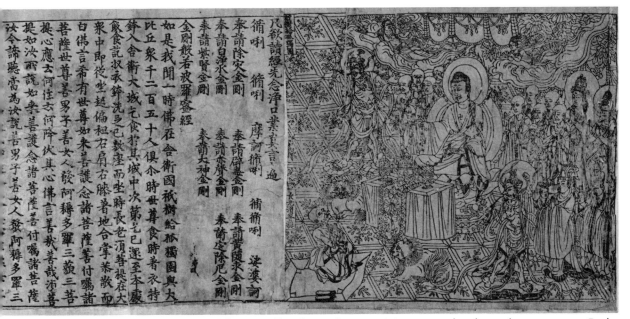

Diamond Sutra. Chinese. A.D. 868. 21½ x 12" (54.6 x 30.5 cm). Length of scroll 17½' (5.3 m). By permission of The British Library, London.

This Buddhist scroll is the earliest surviving example of woodcut on paper. Both the Chinese characters and the illustrations were carved on the same blocks. Water-based ink was used to print the image onto the paper.

EARLY EUROPEAN WOODCUTS

Woodcut was introduced in Europe during the fourteenth century, and woodblocks were soon thereafter employed for printing designs on textiles. Woodblocks used to print on fabrics are often referred to as textile blocks. Fabric printing was done by the stamp method, whereby the inked block was placed face down on the fabric, and then pressed or hammered to transfer the image to the material. Some of the earliest prints on vellum and paper were also believed to have been made this way. Stamp prints, whether produced on fabric or on paper, do not make as crisp or as even an impression as those printed by block printing. Block printing is different from the stamp method in that the woodblock is inked and left face up, and the paper is placed on top and burnished.

The establishment of paper mills during the fourteenth century made inexpensive paper available, and block printing became a simple, practical means of producing pamphlets, single-sheet editions of religious illustrations, playing cards, and books.

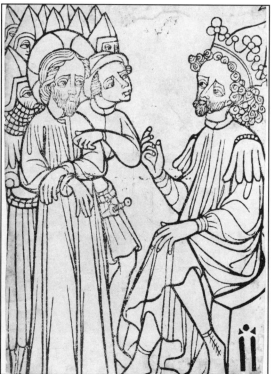

Christ Before Herod. Anonymous. German. C.1400. 15⅝ x 11" (39.7 x 27.9 cm). Reproduced by courtesy of the Trustees of The British Museum, London.

This woodcut was pulled from a woodblock. The broken lines are characteristic of a block printed by the stamp method. One of the more popular uses for printed textiles was for hangings on church reading desks.

Of particular interest are the early religious block books produced before movable type came into use in the mid-fifteenth century. Partial and full pages of text were cut directly into the block along with the illustrations. By modern standards this would seem a laborious method of reproduction, but at this time the duplication of books in any quantity was a welcome innovation because it made it possible for many people to have access to the printed word and illustrations.

Block books reflect the religiosity of Europe at the time. They contained stories from the Bible and moral tales. Images were defined by the black-line technique—the use of bold, black contours—and hand coloring was often employed to enhance the impressions, presumably so that they would more resemble manuscript illumination. There was use of stencils to fill in areas of color, but printing color from separate blocks did not become popular until the mid-sixteenth century.

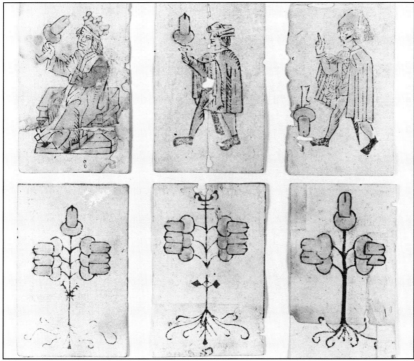

German playing cards: Five, Six, Seven, King, Ober and Unter of Acorns. Fifteenth century. From the collection of The United States Playing Card Museum, U.S. Playing Card Company, Cincinnati, Ohio.

Woodcut was a practical means of producing quantities of playing cards. Dark lines printed in relief defined the image, while hand coloring enhanced it. As many cards as possible were printed on one sheet and then cut up to form the decks.

RENAISSANCE WOODCUTS

During the late fifteenth century and on through the sixteenth, woodcut entered what might be called a golden age. Such notable Northern Renaissance artists as Albrecht Dürer, Albrecht Altdorfer, Hans Holbein, Hans Baldung-Grien, Lucas Van Leyden, and Lucas Cranach combined their talents with those of skilled cutters to produce impressions of superior artistry and craftsmanship.

There is no artist in history who has had a greater impact on the art of woodcut than the German artist Albrecht Dürer. His sophisticated use of black-and-white design coupled with superior draftsmanship set a standard that has seldom been equaled.

Other artists who deserve mention are Swiss printmaker Urs Graf and the Italian Giuseppe Scolari. Both are known for their white line woodcuts, which are reverse-image impressions.

A common practice that began during the Renaissance and lasted into the nineteenth century was for artists to employ cutters and printers to execute their woodcuts, which wer commonly made from the wood of European sycamore and beech trees—both broadleaf hardwoods.

Most drawings were executed directly on th block, although it was not uncommon for a paper drawing to be pasted onto the block for cutting. Cutting through paper can be accomplished with a knife more easily than with gouges. Ink was applied to the relief areas of the block, and most printing was done by press.

Combining multiple blocks to make one large woodcut was a common practice during the Renaissance. Dürer and the Venetian painter Titian both produced elaborate wood cuts in this way. Dürer composed a woodcut of many blocks for Emperor Maximilian that covered 90 square feet.

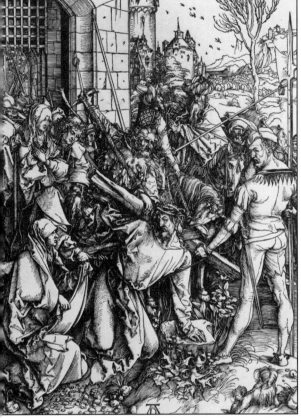

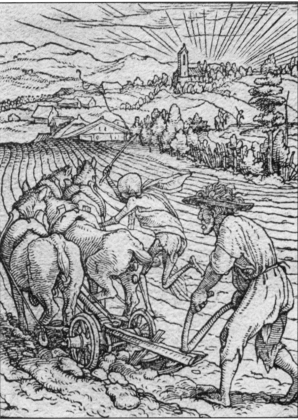

The drama of this event is heightened by the sharp diagonal lines and innumerable contrasts of gray tones from black to white that work through the composition. The linework skillfully follows the direction of the forms, a trademark of Dürer's draftsmanship. The complexity and the angularity of the fabric is characteristic of the Northern Renaissance.

Holbein, most famous as a painter, executed many woodcuts. In his *Dance of Death* series, Death is shown as a skeleton who stalks and confronts individuals of various stations in Renaissance society. Holbein's woodcuts are less complex and smaller than Dürer's, but are as expressive. They both made series that were distributed as single-sheet editions.

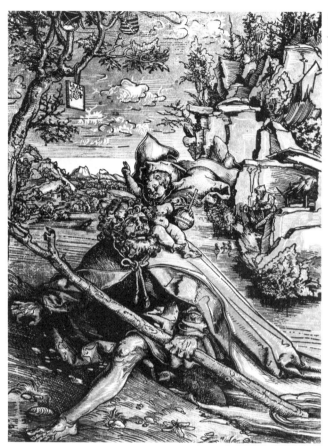

Lucas Cranach. **St. Christopher**. 1502. 11 x 7⅞" (27.9 x 19.4 cm). The Metropolitan Museum of Art, New York. Purchase, Joseph Pulitzer Bequest, 1941.

Lucas Cranach was one of the few early artists to employ the "chiaroscuro" technique of woodcut. A second block was used that was printed in color. This simple form of color printing was derived from chiaroscuro drawing, a technique in which a drawing on toned paper is accented with highlights in white. In the case of woodcut, the highlights are the cut-out areas within the block. In chiaroscuro woodcut, tonal illusions can be created by using a midvalue color, requiring less line.

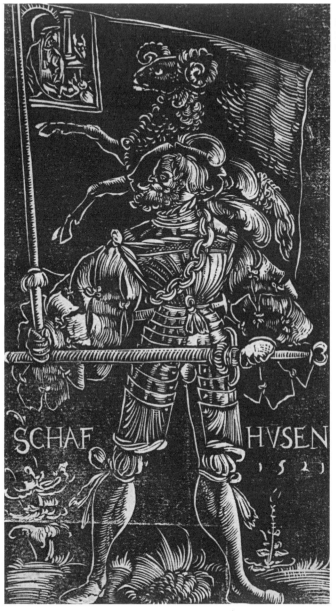

Urs Graf. **Standard Bearer of Schaffhausen**. 1521. 7½ x 4¼" (19.0 x 10.8 cm). Reproduced by courtesy of the Trustees of The British Museum, London.

Urs Graf is best known for his standard bearer subjects. He was one of the first printmakers to employ the white-line technique in woodcuts. This is one of his less complex works.

THE NINETEENTH-CENTURY REVIVAL

The popularity of woodcut declined markedly during the seventeenth and eighteenth centuries. Wood engraving, metal-plate engraving, and intaglio printing (in which ink is applied to incised lines) became the preferred methods for printing book illustrations, as well as single sheet editions. Engraving allowed finer line and crisper detail than cutting did. Through the use of crosshatching and minute dot patterns, engravers were able to create modeled effects and tonal illusions, and the hard surfaces of end-grain wood and metal held up well through the printing of large editions. Prints during this era were thought of as duplicated illustrations rather than as fine art.

A revival of the woodcut occurred during the late nineteenth century with the work of Paul Gauguin and Edvard Munch. Both artists replaced the illustrative nature of woodcut imagery with the expression of individual ideas. Their woodcuts appear crude compared to earlier ones, but their prints cannot be judged according to earlier standards of realism and craftsmanship.

The renewed interest in woodcut can, in part, be attributed to the influx of Japanese prints into Europe during the late nineteenth century. The stylistic and compositional elements in Japanese prints greatly influenced the painters and printmakers of the period.

Although the Japanese have a strong tradition of black-and-white woodcut, they are better known for their superb color printing. The most popular prints were those produced in the *ukiyo-e* style, a genre of imagery that included scenes from everyday life, folklore, landscape and other nature-oriented subjects, as well as traditional scenes.

Both Gauguin and Munch approached their woodcuts aggressively and experimentally, neither disguising the fact that his impressions were pulled from wood. Both artists incorporated the arabesques of Art Nouveau into their compositions. Gauguin experimented with a variety of cutting techniques; he also used scratching and sanding to create textures and tones. His Tahitian woodcuts, for which he is best known, are primitive and symbolic interpretations of the innocence and beliefs of the Polynesian people.

Personal symbolism pervades the woodcut of Edvard Munch. Many of his prints appear to be psychological studies dealing with neurotic relationships between people or lonely individuals trapped in their own neuroses. He was an innovative color printer, often sawing blocks into several pieces, inking them with different colors, and reassembling them before printing. Munch was one of the first artists to incorporate wood-grain patterns into his compositions.

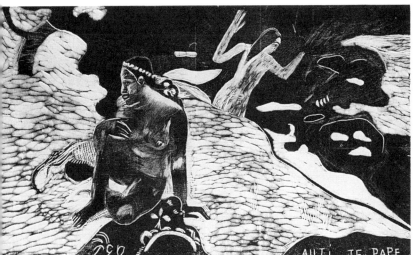

Experimentation abounds in this woodcut. In the central figure the wood has been sanded and scratched to create illusions of light, shadow, and volume. The arabesques appear as abstract elements having little resemblance to representational forms in space. Color was applied by the use of stencils.

aul Gauguin. *Auti Te Pape* ("Women at the iver"). 1891-1893. 8 x 14" (20.3 x 35.5 cm). he Metropolitan Museum of Art , New York. ogers Fund, 1921.

Katsushika Hokusai. *The Great Wave at Kanagawa.* Color. 1823–1829. 10 x 15" (25.4 x 38.1 cm). The Metropolitan Museum of Art, New York. The Howard Mansfield Collection, Rogers Fund, 1936.

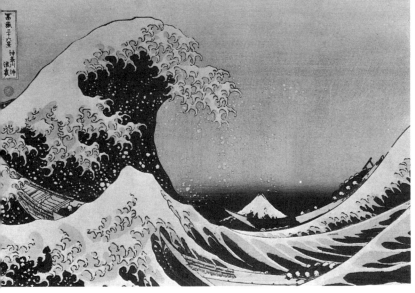

Japanese color woodcuts were printed from separate blocks. Each block carried its own color. Ink was brushed on the block, allowing the block printer to create atmospheric effects and gradations of tone. Hokusai's woodcuts are renowned for their superb design, craftsmanship, and accurate color registration.

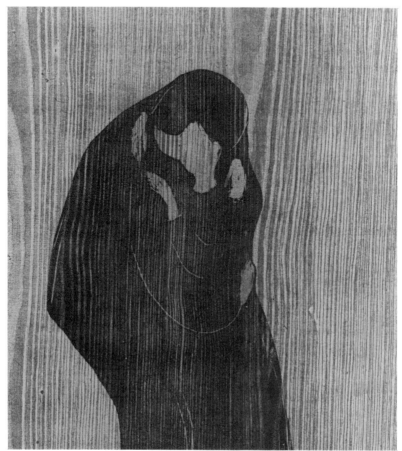

This woodcut was printed from two blocks. The two figures were printed first. Then another heavily grained block was given a very light coat of ink and printed over the two figures.

Edvard Munch. ***The Kiss.*** Color. 1897-1902. 18⅛ x 18¹⁵⁄₁₆" (46.7 x 46.4 cm). Collection, The Museum of Modern Art, New York. Gift of Abby Aldrich Rockefeller.

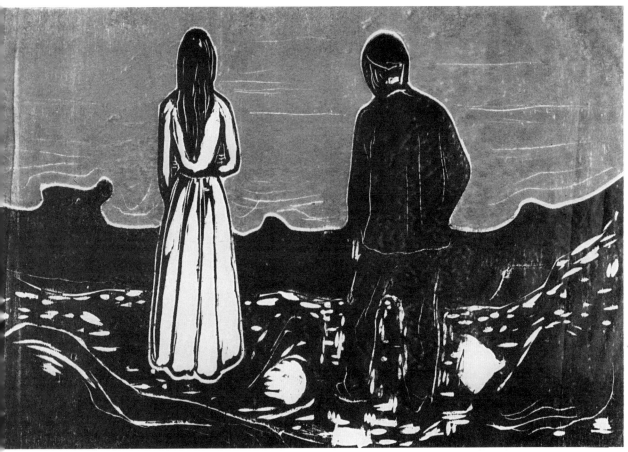

The psychological relationships of men and women was a central theme in much of Munch's work. In *Two Beings,* the figures are separated by a space that suggests that the young woman, symbolically dressed in white, is inaccessible to the man. The woodcut, printed in two colors, was sawed in two pieces along the contours of the ground and the figures. The two pieces were inked separately and then reassembled for printing.

Edvard Munch. **Two Beings** (The Lonely Ones). Color. 1899. 15½ x 23¾" (39.4 x 55.3 cm). Collection, The Museum of Modern Art, New York. Private donation.

THE TWENTIETH CENTURY

During the early years of the twentieth century, a group of architectural students with an interest in painting formed an expressionist group they called Die Brücke (The bridge). Their aim was to bring German art into the twentieth century by disassociating themselves from the traditional art around them. In painting, they were influenced by Fauvism, which featured bold strokes of color applied arbitrarily, and in woodcut, their inspiration was derived from the black-and-white block prints of the Middle Ages.

Die Brücke members included Ernst Ludwig Kirchner, Karl Schmidt-Rottluff, Eric Heckel, Christian Rohlfs, and Emil Nolde. Kirchner was the most prolific member of the group, and his woodcuts are more stylistically varied than those of the others.

Some of the more familiar names in modern art, Pablo Picasso, Henri Matisse, and Franz Marc, also produced woodcuts. Picasso was a prolific printmaker who worked in a variety of media, although he is best known for his color *linocuts*. Matisse's woodcuts are bold linear extensions of his drawings. The woodcuts of Franz Marc are dominated by animal themes, and, like his paintings, often blend elements of geometric abstraction with representational form.

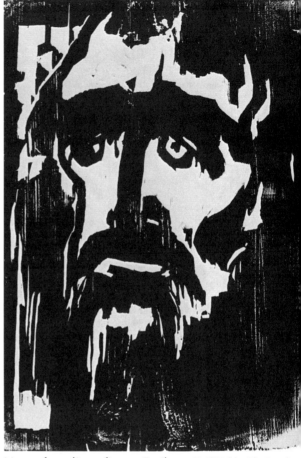

More of a solitary figure, Emil Nolde was associated with Die Brücke for only a short period of time. The influence of early German woodcuts is apparent in the religious orientation of his paintings and prints. The spiritual intensity and graphic impact of *The Prophet* makes it one of the most powerful woodcuts of the early twentieth century.

Emil Nolde. *The Prophet*
Printed in black. 1912.
12⅝ x 8¾" (32.0 x 22.2 c
Collection, The Museum
Modern Art, New York.
Private donation.

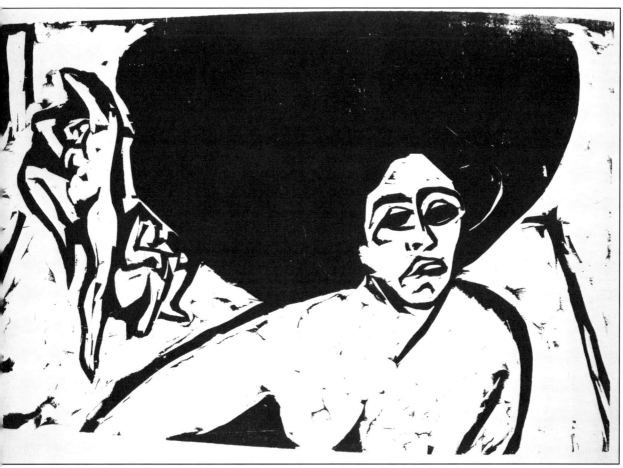

Ernst Ludwig Kirchner. **Nude Dancers**. Printed in black. 1909. 3⅜ × 20⅞" (36.5 x 53.2). Collection, The Museum of Modern Art, New York.

Kirchner's woodcuts vary more in style and design then the other members of Die Brücke. This particular woodcut is characteristic of the spontaneity and immediacy in much of German expressionist work.

Christian Rohlfs. *Two Dancers*, 1913. 11¹⁵/₁₆ x 12 ¹/₈"
(28.7 x 30.8 cm). Collection, The Museum of
Modern Art, New York.

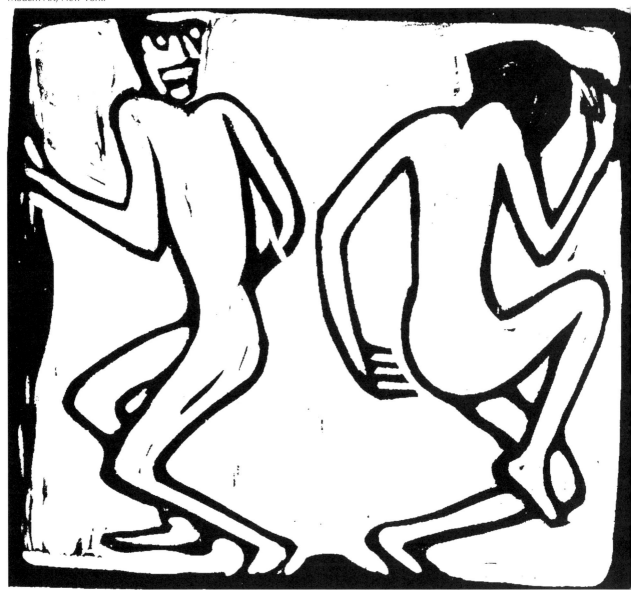

Rohlfs's imagery and style were largely traditional
until exposure to Gauguin, Van Gogh, and expres-
sionism caused a sudden shift in direction. The primi-
tive characteristics of *Two Dancers* are accentuated
by the distortion of the figures and simplified compo-
sition. Experimental uses of paints and inks created
unusual effects in some of Rohlfs's woodcuts.

The active patterns that characterize the art of
Fauvism and Van Gogh are suggested in this ex
sionistic woodcut by Henri Matisse. The immec
of the image and distortions within the figure h
affinity with German expressionism, yet the rep
the figure seems contradictory to the aggressive
of the composition.

enri Matisse. *The Large Woodcut*. 1906. 18¾ x 15"
7.5 x 36.1 cm). Collection, The Museum of Modern
, New York. Gift of Mr. and Mrs. Kirk Askew, Jr.

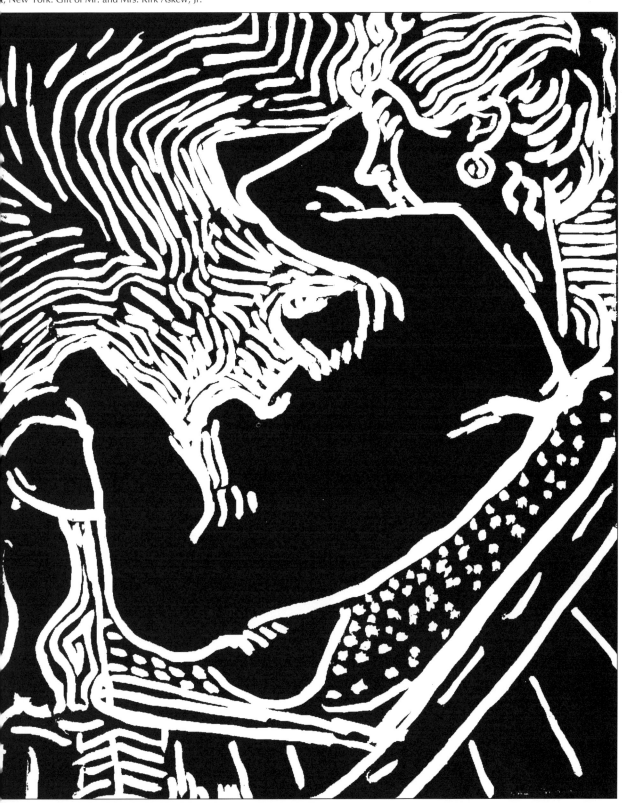

CHAPTER
2

ELEMENTS OF

BLACK

and

WHITE

DESIGN

There are five basic design approaches that you can employ when planning a woodcut: black silhouette, white silhouette, black line, white line, and visual texture. Line and texture may also be used in combination to create the illusion of a tone, an intermediate gray value between black and white. Most designs combine two or more techniques.

BLACK SILHOUETTE AND WHITE SILHOUETTE

Of all design techniques, black silhouette has the strongest graphic impact. This type of design is created by carving out background spaces so that the subject prints black. Compositions based on silhouette should be neither too complex nor simple. One simple example is a solid black circle on a white ground. It has immediate graphic impact, but is of little interest. Other design elements, such as textures or wood-grain patterns, however, can help. You can neutralize overactive designs by printing on toned paper.

A white silhouette is created by carving out the area of the subject so that the background prints black. It rarely has the same degree of impact as a black one. However, white silhouettes can create theatrical effects. If framed by black, for example, they convey an illusion of frontal lighting.

A group of printmaking students volunteered to help demonstrate each of the five basic design approaches. Each student was given an 8-x-10" woodblock and a photograph. I asked each of them to create a woodcut for one of each approach. Included in the examples shown is a woodblock I cut that shows some common compositional errors to be avoided by beginners.

Compositions that exclusively emphasize black silhouettes or white silhouettes have dimensional limitations. Neither will show three-dimensional volumes or light and shadow. If tonal illusion is not used, you can get depth by only showing objects in perspective.

The first two woodcuts (shown on pages 30 and 31) emphasize silhouettes. Objects like the tree and building are instantly perceived as such even though one print shows them as blacks and the other as whites. The objects are recognizable because the areas that surround them are perceived as background. For a design to be successful, you must give these background spaces, or *voids*, as much consideration as the objects. This object-to-background juxtaposition is referred to as a *figure-ground relationship*. This effect will add impact to your work.

This photograph served as the prototype from which the six woodcuts that follow were developed. They illustrate the basic approaches to black-and-white design.

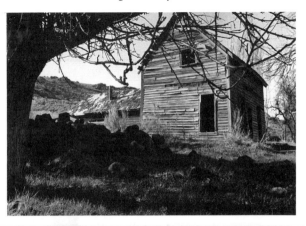

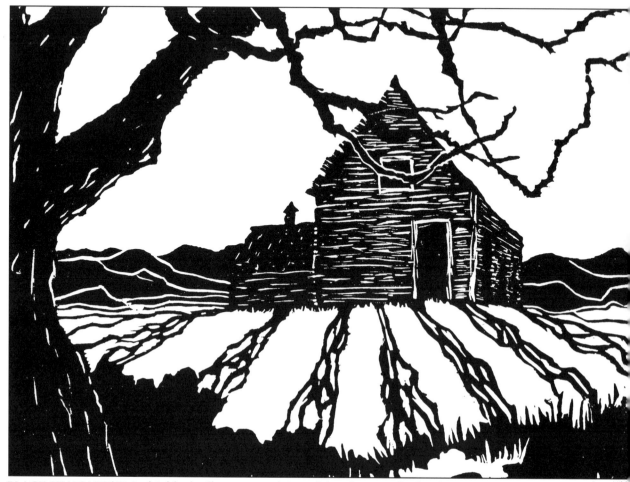

Laura Hibl

BLACK SILHOUETTE In this black silhouette rendition of the photograph, the design is vigorous, but not so complex that it is difficult to view. Jagged contours give an expressionistic character to the forms. The artist altered the photograph's composition to compensate for the spatial limitations imposed by the silhouettes. Note the large size of the tree in relation to the size of the building, and the exaggerated perspective in both the building and the lines in the middle ground. White lines and white silhouettes were added for variety. In both composition and expression, this print is well done. The tree curves upward and over, directing the eye toward the building. The jagged black lines in the foreground area further accent the building as the focal point of the composition. The black silhouette at the base of the tree crosses the lower portion of the print, increasing an illusion of depth between foreground and background.

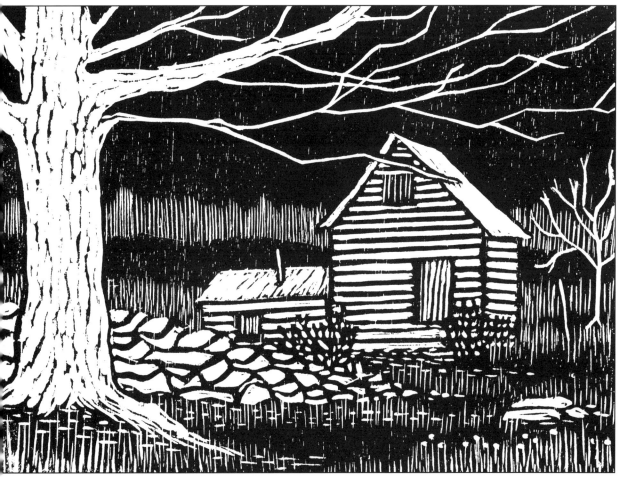

WHITE SILHOUETTE I created this white silhouette print to illustrate some common errors made in designing and cutting. The tree and the building were positioned to show some compositional problems encountered when the figure-ground relationship is not worked out well. The main tree is static and poorly drawn. The uppermost portion is too small. Limbs are too narrow for the bulk of the trunk, and are not drawn in perspective. The lowest limb on the right appears as an afterthought, interjected to make the tree unite with the building. The tree and the building compete for attention, largely because the shape formed by the background is too blocklike; it lacks variety. Narrow white lines in the ground portion of the design are intended to soften contrast and unify the white silhouettes. Unfortunately, they were haphazardly cut.

BLACK LINE AND
WHITE LINE

Black-line woodcuts are an outgrowth of drawing, and in most cases principles of drawing will apply to woodcut. For this reason, linear woodcuts are more often designed as black line on a white background rather than as white line on a black background.

Both black-line and white-line woodcuts can create the same effects as their silhouette counterparts. Just as a silhouetted form is defined by the area that surrounds it, a line is defined by the area adjacent to it. If you place narrow black lines adjacent to broad white lines, the image will be defined by the black lines. Conversely, placing narrow white lines adjacent to broad black lines will give the illusion of design defined by white lines. Narrow lines of equal width will blend optically, creating the illusion of a gray tone. The

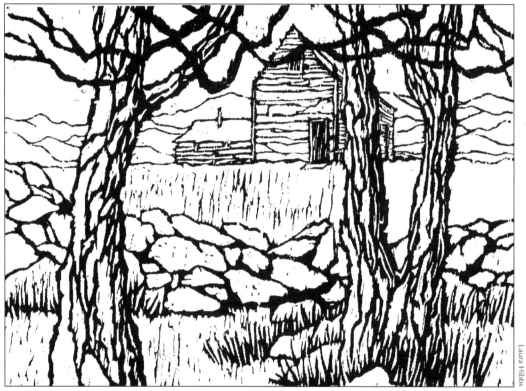

Laura Hibbs

BLACK LINE This woodcut follows one of the oldest traditions in art: the use of line to depict an image and express an idea. Because it was first conceived as a drawing rather than a woodcut, the principles of line drawing have been followed throughout the composition. Trees, rocks, the building, and hills are easily recognized because the lines that define them are graduated in width from foreground to background, wider in the immediate foreground, and narrower in the background. If it were not for this variation in line the design would appear very flat. Also, the gradual reduction in the width of line gives the illusion of gradations and contributes to the illusion of depth. Some indication of light and shadow can be seen on the trees and rocks. The trees appear lighter on the left-hand side than on the right, and the rocks appear lighter toward the top than at the bottom.

er and more precise the lines, the more
en the tone appears.

The initial impression given by a detailed
ite line woodcut is that the artist must
ve spent a lot of time and effort cutting the
ock. However, compared to a detailed black
e approach, the white line approach is
ually faster and more direct because only
one cut is needed to produce a white line,
whereas two cuts are required to produce a
black line. White lines are usually developed
from a black background, a method of work-
ing called *maniére noire*, or "black manner."
This procedure is also used in lithography
and in intaglio printing. In commercial illus-
tration it is called scratchboard.

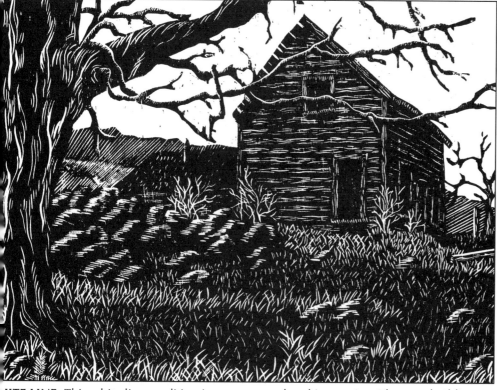

Dana Merril

HITE LINE This white line rendition is most unusual and interesting. The tree, building,
 hills were first delineated as black silhouettes. Within the silhouettes, the artist uses
ite lines to define individual areas and objects. In most cases the lines are cut to con-
 to the direction and contours of the forms. For example, a vertical pattern, represent-
 bark, follows the upward movement of the tree; straighter lines moving across the
ding represent boards; and a scraggly pattern through the ground area represents
ss. Compared to the preceding prints, there is a distinct use of light and shadow that
ears across the grassy areas. If this print has any shortcomings, they would be that not
 he lines conform to the contours of the forms, and that the light and shadow are too
tle for the brightness of the sky.

TEXTURE

In addition to silhouette and line, textures can be employed to add variety or tonalities to a print. Since the artist does not have a range of values or color to work with, textures can play an important role in enhancing a woodcut. Entire compositions can be planned around the interplay of textures. When you design a woodcut with a great deal of visual activity, take care not to overlap excessive varieties of texture, or the result will be total confusion.

You can create textural illusions by using innumerable small dots or lines, by scratching the surface of the wood with a sharp instrument, or by printing from a heavily grained block of wood.

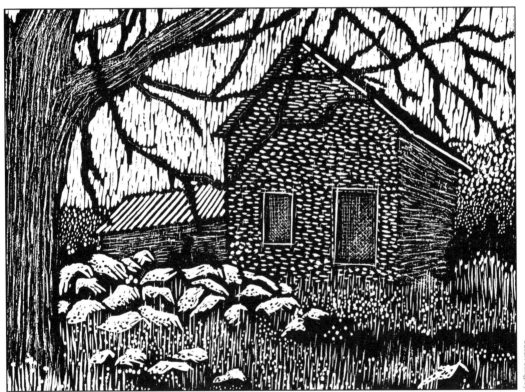

Susan Stingley

In this woodcut almost every area within the design is alive with visual activity, yet the subject is clearly recognizable. The different textures are juxtaposed in such a way that they do not come in direct conflict with each other. There are four compositional devices the artist uses to keep the image under control: 1. Except for the sky, she uses only lines and dots. 2. She alternates the textures. 3. She uses black outlines judiciously and only where necessary to separate the textures. 4. She adds solid areas of black and white throughout the design to give the eyes respite from the textural activity.

COMBINED APPROACHES

When all five basic approaches are combined in one woodcut, the end result can be a sophisticated study or it can be a study in chaos. Silhouettes, lines, and textures must be arranged in such a way that they don't conflict with each other. Experience will give you the ability to do this.

When working with representational subject matter, you can greatly simplify the design by following a consistent light source throughout the composition. A light-side, dark-side rendering of objects produces alternating black-and-white silhouettes, and gives forms the illusion of three-dimensionality.

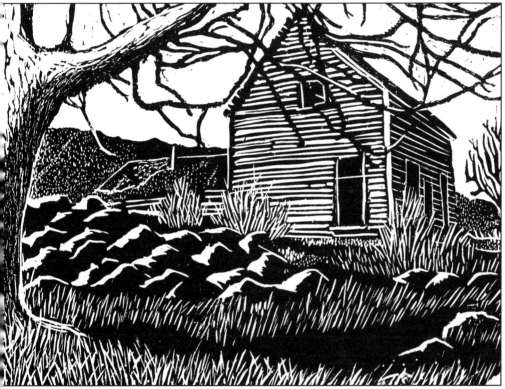

Cheri Mensching

This woodcut has kinship to all the others because it is, in effect, a combination of all of them.

MATERIALS

The supplies list below is divided into three groups: the first, required materials, are those you should have before beginning a project. The second, recommended materials, are those you should obtain at your earliest convenience. The third, special materials, are those required for special methods and techniques discussed in this book.

REQUIRED MATERIALS

ood
t of woodcut tools
Acto knife
utty knife (ink knife)
dia oil stone
x 3″ or larger, hard white Arkansas stone
in-One oil
inch (15.2 cm) brayer
ack oil-based block printing ink
esso
ood filler
blespoon
asking tape
ce paper
ewsprint
or 3-inch paint brush
4-inch square of cardboard)

White glue
Fine sandpaper
Black drawing ink
No. 4 or no. 6 pointed brush
Red Conté crayon
Pencil
Metal yardstick
Scissors
Palette knife
Roll-up glass
Paint thinner
White drawing paper
Masking tape
Crosscut handsaw
Clean-up rags
Permanent black marking pens
(also called "felt-tip" pens)

RECOMMENDED MATERIALS

and 4-inch brayer
acksaw or equivalent
o. 8 pointed brush
ood for bench hooks
ips or leather strap
othbrush or stiff brush

Linseed oil
Alcohol (denatured or rubbing)
Transparent-base ink
24-inch (61 cm) metal square
Apron or smock

3. SPECIAL MATERIALS

Modeling paste

Rubber cement

Contact cement

Lacquer thinner

Charcoal pencil

Charcoal fixative

Acrylic gloss or mat media

Japan or cobalt dryer

Latex gloves

Large carving or sculpture tools

Wooden mallet

Sharpening guide

C–clamps

Power saw

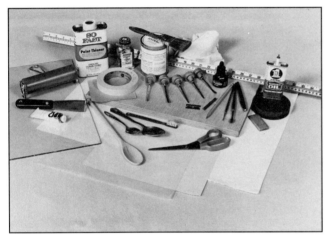

The basic required
materials for woodcut

TYPES OF WOOD

Woods can be divided into two primary groups, those from broadleaf, or deciduous, trees, and those from needleleaf, or coniferous, trees. In the forest industry, broadleaf trees are generically referred to as hardwoods regardless of how hard or soft the wood might actually be. Needleleaf trees are referred to as softwoods. For instance, poplar is actually a soft wood, but because it is a broadleaf tree, it is placed in the same category as the maple, which is quite hard. Except for a few species, all needleleaf woods are soft in fact as well as in classification.

Before you begin a woodcut, you must select the proper type of wood for your pro-ject. It may be tempting to use any scrap lumber at hand; however, scrap lumber is often so flawed that the imperfections will not allow you to have full command over the medium. In particular, avoid common Douglas fir plywood, which is used in the building industry. It is the least desirable material for woodcut because it will print a very strong grain pattern. (It should be used exclusively for that effect.) Other woods that do not work well generally are walnut, oak, maple, and balsa wood. But this does not mean that all scrap lumber is unsuitable for woodcut; it just requires a little knowledge to determine what is usable.

BIRCH

In contrast to ordinary plywood, a good-quality birch veneer is smooth and evenly grained, splinter resistant, and easily cut. It holds up through repeated printings, produces fine details with crisp edges, and does not absorb an excessive quantity of ink. Because birch is very hard you will need to sharpen the tools occasionally when using it.

Birch plywood is used primarily for cabinetmaking, and the higher grades should have two sides of equal quality. If this is not the case with the block you have, use the smooth side for detailed cutting, and the coarser side for bold work. Although ¾-inch (1.9 cm) plywood affords great stability while cutting, you can use thinner sheets to reduce your expenses.

There can be some drawbacks to plywood as well. Hollow spots under the veneer can cause a tool to break through the surface, and some manufacturers produce veneers so thin that the wood tends to splinter when cut. Use a very sharp blade made for cutting plywood, or saw to keep from splitting the veneer surface. You may be able to find odds and ends of birch at cabinet shops or lumberyards. Teachers may find a 4-x-8-foot (122 x 244 cm) sheet not unreasonable in price, considering the many two-sided blocks that can be cut from a single sheet.

PINE

Another wood product that is readily available is 1-x-12-inch (2.5 x 30.5 cm) pine board. Although it is not free of knots, a pine board can be cut into sections and you can discard the knotted portions.

Choose pieces that are not bowed and have no broad areas of dark grain or raised grain. Pine with an excessive number of narrow and dark lines of grain running lengthwise through the board is also not desirable. Despite pine's drawbacks , it cuts easily, leaving a good wood-grain pattern.

Other usable pine boards that are available from some lumber outlets are knotless pine shelving and pine panels. Pine panels usually contain some knots. They come in 4-foot (1.2 m) lengths and in widths from as narrow as 13 inches (33 cm) to as wide as 36 inches (91.4 cm). The larger panels consist of laminated boards, but the laminates have little effect on the cutting or printing. The type of pine wood available can vary throughout the United States depending on the species harvested and milled locally.

POPLAR AND BASSWOOD

Poplar is smooth and lightly grained, and it cuts effortlessly both along and across the grain. Unfortunately, it may be more difficult to find than birch or pine, especially in the far northern and western United States.

Basswood is most readily available in the form of drawing boards, which are quite expensive in comparison to other woods. Some printmakers consider drawing boards well worth the price because basswood is exceptionally smooth, and cuts equally well both along and across the grain. Solid basswood boards are becoming increasingly difficult to find, however. The less expensive boards now have hollow cores and the veneer surface is too thin for woodcut.

Both poplar and basswood are referred to as whitewood because of their color. Besides being alike in color, they are alike in texture and density. Beginners may find them suitable as woodblocks.

Precut ¼-inch (.64 cm) blocks of whitewood are available from some suppliers that carry printmaking materials. These suppliers may also offer precut mahogany blocks, but because of its grainy nature, mahogany can print a white flecklike pattern throughout the impression. Whitewood and mahogany do not lend themselves to the spoon printing (see p. 95) of large editions. The rubbing action of the spoon can cause the edges of cut areas to become rounded, thus losing the sharpness of detail in the print.

OTHER WOOD PRODUCTS

Plank-grain cherrywood (similar to that used in traditional Japanese woodcut) can be obtained from some wood-product suppliers in the form of narrow boards of around 8 inches in width.

There are a variety of wood veneer-surfaced products manufactured for non-art purposes. Browsing through woodworking, craft, or hobby shops can sometimes yield pine or other soft wood-surfaced boards suitable for woodcut.

WOOD FILLER

A good quality wood filler, such as Elmer's Professional Carpenter's Wood Filler, should be used to repair cutting mistakes. Plastic wood or modeling paste can also be used, but they have drawbacks that make them less desirable than wood filler.

TOOLS

Bear in mind that tools play the most important part in the woodcut process. The quality of a tool is only as good as the quality of the steel it is made from. Carving tools, which are normally sold in five- or six-piece sets, can range in price from a few dollars to well over $50. Cheap sets are best avoided because they seldom perform their intended functions. The adage "you get what you pay for" is relevant to the purchase of woodcut tools.

You can buy good-quality tools at moderate prices, but I will refrain from recommending any specific brands because there is no guarantee that quality control in manufacturing is maintained from year to year. If at all possible, test the tools before purchasing.

Woodcut tools are normally numbered according to the widths of the cutting tips measured in millimeters. The standard set of palm-grip tools pictured below is satisfactory for most work.

If you wish to add to your collection of tools, individual tools are available from some printmaking and wood-carving suppliers. Woodworking suppliers offer a wide range of cutting widths from as small as one millimeter to as large as two inches (50.8 mm.).

The terms woodcutting and wood carving are often used synonymously, but tools specifically designed for block printing are usually labeled as woodcutting tools. Some wood-carving tools will have tip shapes, handle styles, nomenclature, and numbering systems that differ from woodcut tools. For this reason, do not attempt to order tools out of a catalog unless the actual tip configurations and widths of the cutting tips are shown.

Woodcut tools have two basic grip, or handle, designs. The palm-grip style is characteristic of European and American tools, and the longer slender grip characterizes Japanese tools. Selecting handle styles is simply a matter of personal preference.

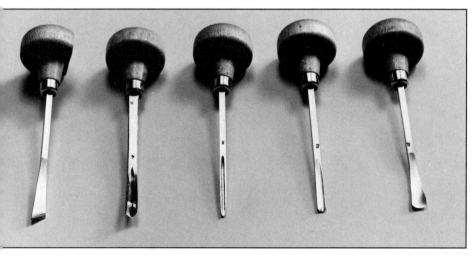

A standard five-piece set of palm-grip woodcut tools. From left to right: a double-beveled knife; no. 4 V-gouge; no. 2 U-gouge; no. 6 C-gouge; no. 8 C-gouge.

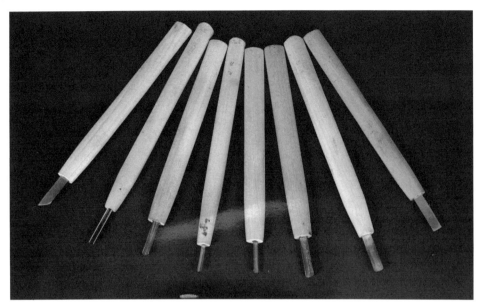

Japanese carving tools. From left to right: right-hand beveled knife; 3mm and 5mm V-gouges; 3mm, 4mm, 6mm, and 7mm C-gouges; chisel.

X-ACTO KNIFE

In addition to woodcut tools, an X-Acto knife or the equivalent will prove an invaluable tool for scoring the block before cutting. This knife will serve a variety of other purposes as well, from sharpening pencils to cutting paper and cardboard.

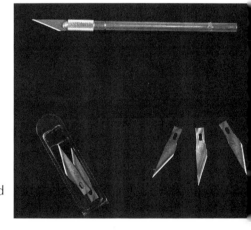

An X-Acto knife and various blades.

LARGE CARVING TOOLS

Although large gouges do not work well on plywood, if you begin working with solid wood on a large scale, you should have at least one or two large gouges and a chisel. The numbering system used for large carving and sculpture tools is different from the one used for smaller woodcut tools. Gouges are numbered according to the depth of their sweep, or scoop. For example, a no. 5 gouge has much less sweep than a no. 10 gouge; it will make a shallower groove in the wood. Number designations will vary from manufacturer to manufacturer. A U-gouge should have a deeper sweep than that of a smaller woodcut C-gouge tool but slightly less than that of a V-gouge.

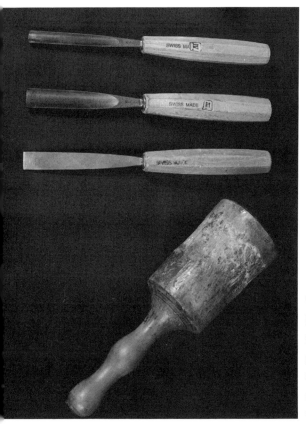

Wood-carving or sculpture gouges can save time and labor for cutting on large blocks. Three tools are satisfactory for most work: 10mm U-gouge; 16mm U-gouge; 16mm chisel. A chisel is convenient for shaving off ridges left by the gouges or for splitting-out large areas of plywood. You may need a wooden mallet when you use gouges of 16mm or larger.

SHARPENING STONES

You should have at least two types of sharpening stones: an India oil stone, and a hard white Arkansas stone. The coarser oil stone will suffice to sharpen tools, but a smoother Arkansas stone is desirable to add keenness and refinement to cutting edges.

Two-sided India oil stones can be obtained in rectangular or round styles. The coarse side of the stone is used for restoring tool tips, and the smooth side for sharpening. Hard white Arkansas stones are expensive, so it is not uncommon to find them as small as 1-x-3-inch (2.5 x 7.6 cm). These stones can be purchased from printmaking suppliers, woodworking suppliers, or sporting goods or department stores. Use a lightweight engine oil, such as 3-in-One oil, on the stone when sharpening a tool to reduce friction.

A rotating sharpening system called a Tri-Stone features three coarsenesses of stones mounted on a triangular block. This arrangement is especially good in classroom situations where individual stones are more apt to be lost or misplaced.

Some woodworking suppliers offer mechanical sharpening guides that hold tools in a fixed position while they are being sharpened. Such devices can be practical for individuals who have difficulty in sharpening tools properly or in situations where a number of tools must be restored.

Sharpening stones should be cleaned periodically with lacquer thinner or a strong mixture of detergent and water. Allow them to dry thoroughly before applying more oil.

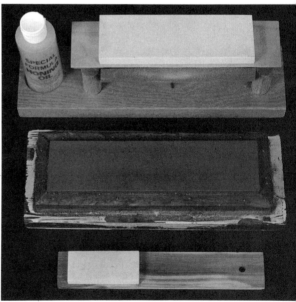

For proper sharpening and the occasional refacing of tools, you should have at least two stones: a double-sided India oil stone and a hard white Arkansas stone.

Other types of sharpening stones that work well for woodcut , from top to bottom: Tri-Stone sharpening system; rectangular oil stone with a wooden support around it; a very small hard white Arkansas stone; tri angular and round slips used to remove burrs from th inside edges of the gouges.

SLIPS AND STROPS

Slips are small sharpening stones designed to remove burrs that can form on the inside cutting edges of tools. Slips are available from some printmaking suppliers, or you can make them yourself by tapering the edge of a small sharpening stone on a grinding wheel. Since the function of a slip is only to remove burrs, the type of stone used is not critical as long as it is not too coarse. A used barber's razor strop or a stiff leather belt will serve the same purpose. The leather can be cut into a 3- or 4-inch strip, allowing it to be used in a similar manner as a slip. Rub the tool briskly against the slip until burrs disappear.

BRAYERS

A brayer is an inking roller with one handle. Brayers may be obtained from ¼ inch up to 10-inches in length. As a general rule, the larger the block, the larger the brayer you should use. For most work a 6-inch brayer is satisfactory, although having a range of sizes on hand from 2-inches up to 8-inches in length is desirable. Brayers over 8-inches long can be awkward to use. An assortment of brayers is shown in the photograph below.

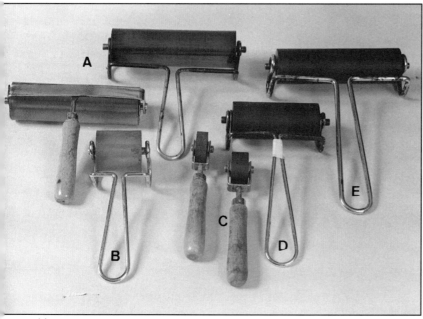

Assorted brayers: **A** two styles of 6-inch urethane brayers; **B** 2-inch urethane brayer; **C** two small rubber brayers; **D** 4-inch black rubber brayer; **E** 6-inch black rubber brayer.

URETHANE BRAYERS

Urethane brayers are the finest inking devices on the market today. They are durable and nonporous, and they hold their shape. Neither too hard nor too soft, they preserve fine detail during roll-up while nevertheless filling in the pores of the wood. They are expensive compared to other brayers, but well worth the price. Urethane brayers should not be allowed to come in contact with any solvents besides paint thinner or turpentine; they will disintegrate upon contact with acids.

SOFT RUBBER BRAYERS

Good-quality soft rubber brayers will perform as well as urethane brayers, but they are more porous and less durable.

Small, soft red rubber brayers, usually sold in art supply stores, can be used to roll-up blocks around 8-x-10-inches and under. Check these inexpensive brayers before you purchase them to make sure they have no concave areas in the center. A simple way to check a brayer is to place it on a flat surface with the handle held upright. Push down lightly on the handle, and then attempt to push the corner of a piece of paper under the brayer. Slide the paper along the length of the brayer; if it slides easily under the center portion, but not at the ends, the brayer is concave. Another method of checking is to position the brayer in the same manner as described above, but facing a light source. Focus your line of sight on the area where the brayer and surface meet. Light should not penetrate the center portion of the brayer.

OTHER TYPES OF BRAYERS

Hard rubber brayers are the least desirable for block printing. They require a lot of pressure to force ink into the pores of the wood, and they have a tendency to slide rather than roll. Neoprene brayers have a good affinity for ink, but they become excessively soft over a period of time. Gelatin brayers are easily damaged. They are too soft for most work, although they are good for rolling–up areas of solid color.

he least expensive saw obtainable for cutng wood blocks is an ordinary crosscut ndsaw. A sharp saw will significantly reduce e amount of time and labor required to cut ocks by hand. Older saws that have not en used for a time may need sharpening.

You may also have need of a fine-tooth saw to cut wooden repair plugs. There are a number of saws for that purpose, the most common is the ordinary hacksaw. A small utility hacksaw can also be used; it is inexpensive and easily stored with your other woodcut materials.

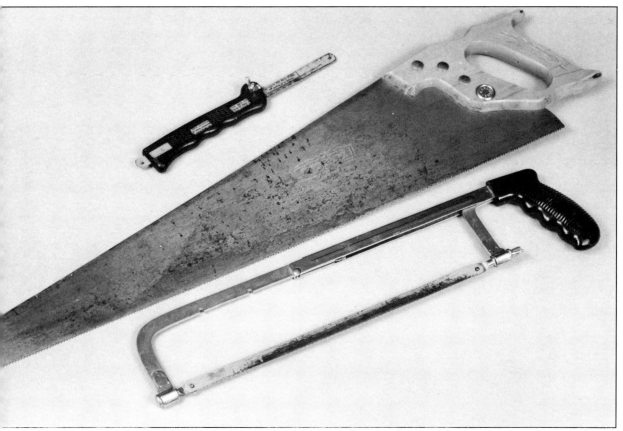

A small utility hacksaw, a crosscut handsaw, and a standard hacksaw. Hacksaws are good for cutting repair plugs.

POWER SAWS

If you are going to do a considerable amount of cutting, having some type of power equipment may be essential. For cutting large plywood or solid wood panels, I recommend using a circular saw. For general use, a saber or jigsaw is practical and inexpensive. It does not cut as rapidly as a circular saw, but it is lightweight and easy to use. It will also cut curves and irregular shapes and can be fitted with a variety of blades for the cutting of woods, plastics, or metals. A saber saw will not produce as straight an edge as a circular or table saw, and some sanding may be required to remove slight irregularities from the sides of the block.

Some people find any power equipment too formidable and prefer to have their blocks cut by a professional. There are lumberyards, woodworking shops, and cabinet shops that will cut wood for a nominal fee.

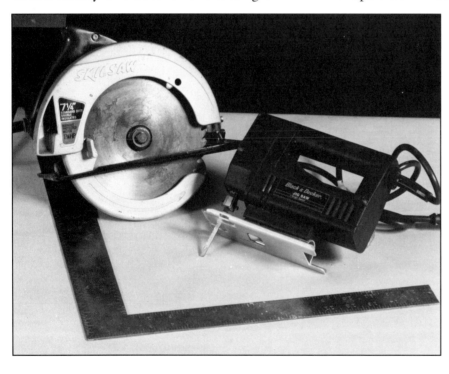

A 7¼-inch (18.4 cm) circular saw, a saber or jigsaw, and a metal carpenter's square.

METAL CARPENTER'S SQUARE

A 24-inch (61 cm) metal carpenter's square may be used to square-up and measure blocks before cutting. If a large number of blocks are to be cut, a metal square will prove a worthwhile investment. A square can also be used for measuring and cutting mats. For the occasional squaring of boards a cardboard rectangle can be used as a substitute.

SPOONS AND BARENS

Generally speaking, any smooth, clean object will serve as a burnishing device. Metal or wooden spoons have been the standard for years, if for no other reason than that you need only raid a kitchen drawer to find one. Metal spoons, preferably stainless steel tablespoons, produce deep blacks. Wooden spoons produce both solid blacks and gray tones.

The term *baren* is used to identify burnishing devices that are specifically designed for use on wood blocks. They are disks covered with bamboo, Teflon, plastic, or some other material. A baren requires less effort to use than a spoon, but most will not produce a deep black unless a considerable amount of ink is applied to the block. Barens are normally used for printing on damp paper with water-soluble ink. A baren can be manufactured for the express purpose of printing grayish tones.

You can easily make a baren for printing gray tones:

1 Cut a 4-inch (10.2 cm) disk from a ³/₄-inch (1.9 cm) block of wood. Cut a 4-to 5-inch section of wood from a broom handle or dowel. Attach the handle to the disk with two screws. Countersink the heads of the screws into the disk.

2 Cut a 4-inch (10.2 cm) circle from a remnant of closely woven carpeting; or make a ¹/₄-inch (.64cm) thick pad by using several layers of felt or old etching blanket. Bond the pad to the disk with glue or contact cement.

3 Cut a circle from a sheet of plastic; polyvinyl is best, but a heavy-duty trash sack will suffice. Wrap the plastic over the disk and secure it to the handle with string or wire. Replace the plastic when it wears.

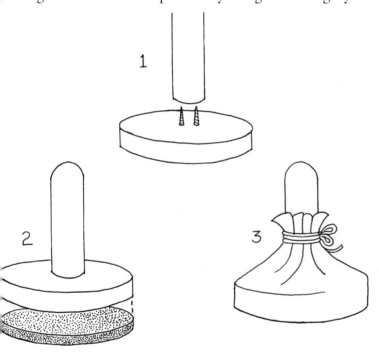

ROLL-UP GLASS

An 11-x-14-inch or larger sheet of ordinary glass can be used to roll-up the ink. Glass can be obtained from a glass company, or you can use a piece of picture glass taken out of an old frame. A good source for inexpensive glass is a thrift store. A sheet of Formica, heavy plastic, or Plexiglass can be used as a substitute for glass.

PRINTING INKS

Oil-based inks are preferred for woodcut because of their compatibility with wood. They will not stiffen over an extended printing time, and the oil in the ink, coupled with the paint thinner used in clean-up, acts as a wood preservative. Most inks contain carbon black made from natural gas or oil. This pigment is very dense and permanent, and its fine texture allows ink to roll evenly.

Inks are available in tubes and one-pound cans. Tube-type inks are usually more practical for individual use, while canned inks are more economical. Canned inks have some disadvantages: they can dry-up over a period of time, and they are easily contaminated with woodchips and dried ink particles. Spray with an antiskinning agent to help prevent drying in the can.

Speedball and IPI are two of the more popular tube-type inks. Canned inks are available from Graphic Chemical and Ink Co., IPI, and Rembrandt Graphic Arts. Another ink of superior quality is manufactured and sold by Daniel Smith Inc.

Black oil-based block-printing inks are available in tubes or one-pound cans.

WATER-SOLUBLE INKS

If you decide to use water-soluble ink, the block should first be given a coat of shellac or spray lacquer. Some printmakers will shellac a block regardless of what type of ink is being used. This eases cutting somewhat and lessens the absorption of ink into the block.

I believe a richer, more even tone of black is obtained by not shellacking the block and by the use of oil-based ink. Blocks on which water-soluble inks have been used should be cleaned with a damp cloth and not flooded with water, which can harm wood.

DRAWING INK

A permanent black drawing ink, such as Higgins' India ink, should be used for drawing on the block. Its permanence allows a block to be proofed during the cutting stage; the image will not be eradicated when the

block is cleaned with paint thinner following the proofing process. Permanent black markers, such as Sanford Sharpie and Sanford King Size, can be used independently or in conjunction with drawing ink.

TRANSPARENT BASE OR TRANSPARENT WHITE INK

Transparent base, transparent white, or extender are ink-base substances containing no pigments. They have more "tack" than black ink: when added to black they will aid in adhering the paper to the block, reducing slippage. Keep a tube at hand.

PRINTING PAPERS

In recent years there has been an increasing interest in papermaking as an art form. This has led many printmakers to focus their attention on fine papers to enhance the overall quality of their prints. Most papers that have some degree of absorbency and are not too heavily textured will work for woodcut, particularly papers with a high rag content. Smooth, gloss-surface papers do not print well.

RICE PAPER

I recommend using rice paper until you have gained some experience in printing. A good-quality rice paper such as Goyu is absorbent and durable. It adheres well to the block during burnishing. Because the paper is somewhat transparent, the image will show through the back side. This is of great advantage, because the printmaker can see where to rub to adhere the image to the paper. Other popular rice papers are Mulberry, Moriki, and Troya. Another paper, Hosho, is thick and very absorbent. Hosho requires more ink for printing, and it has a tendency to slip on the block. Nevertheless, it can help you achieve deep blacks and rich gray tones and is an excellent paper for color printing.

Despite their name, rice papers are not made from rice, but are handmade from plants or tree bark. Mulberry, for instance, is made from the mulberry tree's inner bark .

Rag papers are made from cotton or linen. A few common rag papers that will work well for woodcut are Arches Cover, Domestic Etching, Rives Heavy, and Rives BFK. Arches Cover is available in white and buff, and BFK in white, gray, and tan.

NEWSPRINT

Newsprint is good for proofing woodcuts, but since it yellows and deteriorates, impressions on it are best discarded. Newsprint absorbs less ink than rice paper, so trial prints "pulled" on it will invariably print much darker than first impressions made on high-quality rice papers.

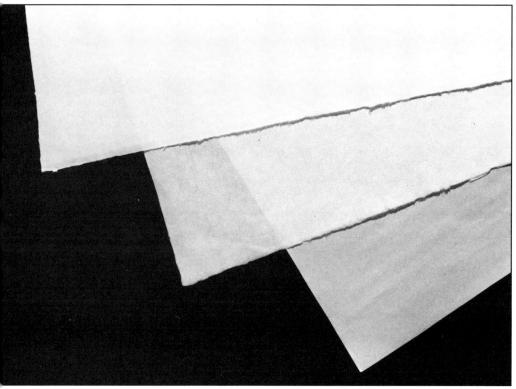

Three popular papers for printing woodcuts. From top to bottom: newsprint, used for proofing; Goyu, a thin rice paper; Hosho, a thick rice paper. The black background shows the papers' degree of opacity.

CHAPTER
4

PREPARING THE BLOCK

The first step in preparing a block is to determine its size. The length and width can be cut to conform to a preconceived idea, or the block can be cut first and the design can then be planned to conform to its proportions. Blocks may be cut to the dimensions of the print papers. Regardless of which approach you choose, I recommend using a block no smaller than 6 x 8 inches and no larger than 10 x 12 inches for your first woodcut. Working within these parameters allows control over the media.

You may find it practical, providing it is not creatively restricting, to coordinate print papers and block sizes with mats and frames. Some people find it convenient to use precut mats and standard-size frames that are manufactured in many modular sizes.

CUTTING OUT A BLOCK

The board or panel a block is to be cut from should first be checked to make sure that it is square. If it is not, square the corner that you plan to cut from before marking the dimensions of the block. Use either a metal or cardboard square to realign and mark one side of the board. Before cutting out a block, doublecheck the measurements to make sure they are square. There is nothing more frustrating than attempting to mat an impression pulled from an irregularly shaped block. After the dimensions are laid out, use either a handsaw or power saw to cut out the block, making sure to securely support the wood from below when you are cutting to prevent it from splitting.

Before cutting a block from a larger board, check to make sure the edges are square. If not, trim the board before you lay out the dimensions of the block.

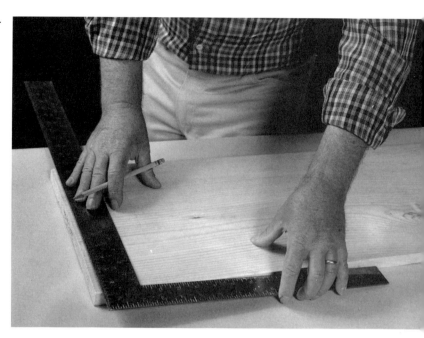

When using a saber saw follow the line of the cut as accurately as possible. Hold the outside portion of the block when nearing the end of the cut.

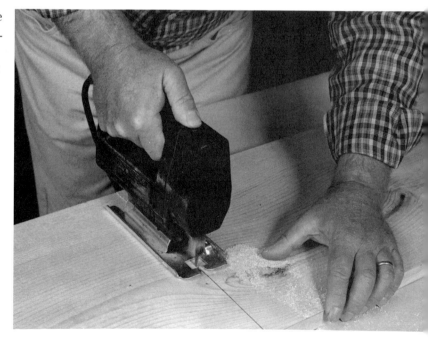

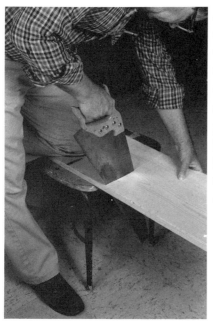

A chair works well as a support for the board while you cut. To keep the wood from splitting when you near the end of the cut, firmly support both outside and inside portions of the board. Saw the last $1/2$-inch of the wood very lightly.

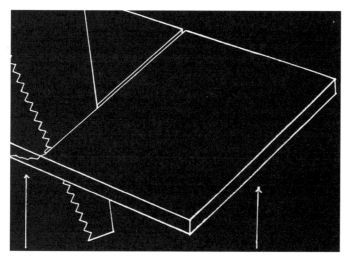

The wood will split here if improperly cut and supported.

Support the outside portion of the board when nearing the end of a cut.

PREPARING THE SURFACE

The surface treatment given to a block is determined by the design. For most designs, a white gesso ground is recommended (*gesso* is a white paste-like mixture of plaster of paris and glue); for fine white-line designs, use a black ground (a *black ground* is a thin coat of black drawing ink or black printing ink). For impressions that will show the grain pattern, no treatment is needed.

GESSO GROUNDS

Gesso is used to prepare a block for all types of designs, with the exception of white-line woodcuts. It leaves a smooth white surface that covers the wood grain entirely. There are four advantages to coating a block with gesso: 1. The design drawn in black on the block shows a clearly defined image to determine where cuts are to be made. 2. Cuts made into the block will be clearly visible, contrasted against the white ground. 3. The block will clean up more easily after printing. 4. Neither the gesso ground nor the drawn image will be erased with paint thinner, so if you take proofs during the cutting stage, you will not lose the image.

New gesso may be applied directly from the can. But since gesso has a propensity to thicken with age it may have to be thinned with water. Ideally, the gesso should have the consistency of a heavy cream. At this thickness, one coat should be sufficient to cover.

METHOD 1: APPLYING GESSO WITH A BRUSH

Gesso should be applied as evenly and smoothly as possible. Brushstrokes of dried gesso are extremely difficult to remove, and if left on the block they will show in the impression.

STEP 1 Lightly sand the surface of the block and wipe it clean with a cloth.

ATERIALS: Gesso; 2″ or 3″ brush, or 3″ to 5″
⌐are of cardboard; fine sandpaper; cloth.

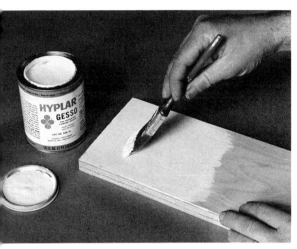

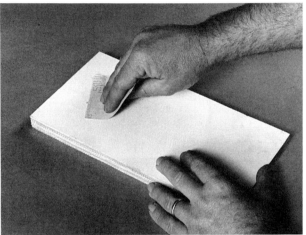

EP 2 Paint a thin coat of gesso across the surface
the block, following the grain of the wood. You
⌐uld not need a second coat unless the gesso is
⌐ceedingly thin.

STEP 3 After the gesso has dried, sand it lightly until
smooth. The other side of the block can also be pre-
pared this way for future use.

METHOD 2: APPLYING GESSO WITH CARDBOARD

MATERIALS: Gesso; a 3–5-inch square of cardboard; fine sandpaper; cloth.

A quick and effective means of spreading an even coat of gesso is to use a 3– 5-inch square of mat board or illustration board. Gesso applied by this method may be thicker than that applied by brush.

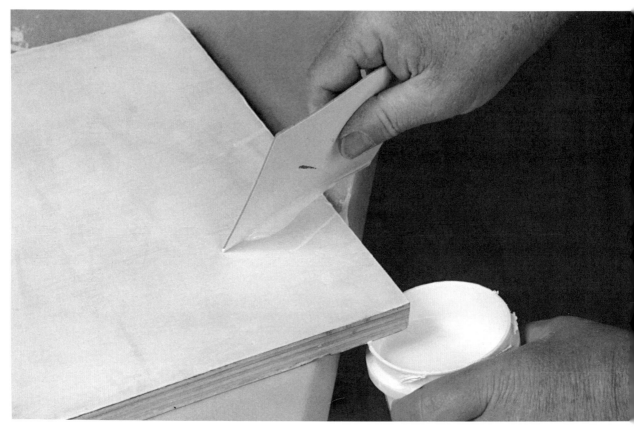

STEP 1 To apply gesso with cardboard, first position the block so that a corner overlaps the table you're working on. Place some newspaper on the floor underneath the block.

STEP 2 Pour a small quantity of gesso near the top center portion of the block. Using the edge of the cardboard, spread the gesso thinly and evenly over the surface while working it toward the corner of the block. Smooth flat any ridges of gesso that form on the surface. Scrap excess gesso back into the container. Wipe off the sides of the block.

STEP 3 Allow the gesso to dry thoroughly, and then lightly san it smooth.

n excellent cutting surface for white-line
oodcuts is a block that has been rolled up
ith a thin but dense coat of printing ink.
he black printing ink that forms the black
:ound is rolled up on the block and allowed

to dry, creating an excellent surface for print-
ing without picking up the wood grain.

After a black ground has dried, the outline
of your design can be traced onto the block
with red Conté crayon.

ETHOD 1: APPLYING A BLACK GROUND

ie use of a black ground to eliminate irregularities in
e printing surface has one disadvantage; you must
ait for the ink to dry, and this can take from several
iys to more than a week. Several drops of Japan or
•balt dryer can be added to the ink to hasten the
ocess. If you intend to do a series of white-line
oodcuts over a period of time, consider using this
ethod to prepare a number of blocks at one time.

MATERIALS: Black printing ink; ink knife; ink glass;
6-inch brayer; soft cloth.

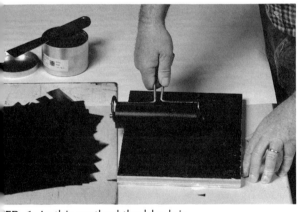

EP 1 In this method the block is
led up with a thin, even coat of
inting ink.

STEP 2 After the block has been
rolled up, blot it thoroughly with a
sheet of newsprint. Rub the back of
the paper with your fist or the heel
of your hand to remove as much
excess ink as possible.

METHOD 2: APPLYING A QUICK-DRY BLACK GROUND

MATERIALS: Black printing ink; ink knife; ink glass 6-inch brayer; paint thinner; soft cloth.

This alternative method will not produce as deep a black as Method 1, but it will quickly create a good surface for cutting. Roll the block with ink and then rub it down with a cloth and paint thinner. The block will usually dry within an hour or two.

STEP 1 Roll the block up evenly with printing ink.

STEP 2 Rub the ink into the block using a cloth saturated with paint thinner. Wipe the block as dry as possible with a clean cloth.

METHOD 3: APPLYING A BLACK GROUND WITH DRAWING INK

MATERIALS: Black drawing ink; no. 6 or no. 8 brush; fine sandpaper.

The most expedient method of applying a black ground to a block is to paint the surface with drawing ink. The ink should be brushed evenly over the surface and be no heavier than necessary. The wetness of the ink can distort the texture of the wood.

Paint the block with an even coat of black drawing ink. After the ink has dried, sand the block very lightly with fine sandpaper.

NO GROUNDS

Using a gesso or an ink ground on blocks will reduce the grain pattern of the wood. If the wood grain is to become an integral part of the design, then a very light sanding is all that is needed to prepare the block. The methods of drawing, transferring, and cutting are the same for blocks without grounds as for gesso ground blocks.

DRAWING

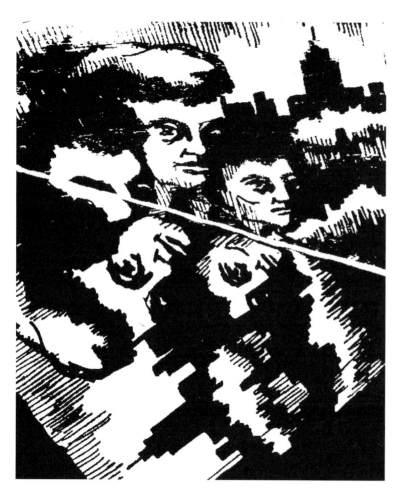

AND

TRANSFERRING

egardless which method of drawing and transferring you use to establish a design on the block, you can save both time and materials by first making one or more preliminary sketches. This will allow you to work out the composition before developing a larger, more detailed drawing.

If possible, plan your design so that most of the cutting can be done along the grain of the wood. While you draw, keep in mind that the white areas will be cut out from the block, and the black areas will be raised and printed. Use black ink and/or a black marking pen for drawing on both paper and block.

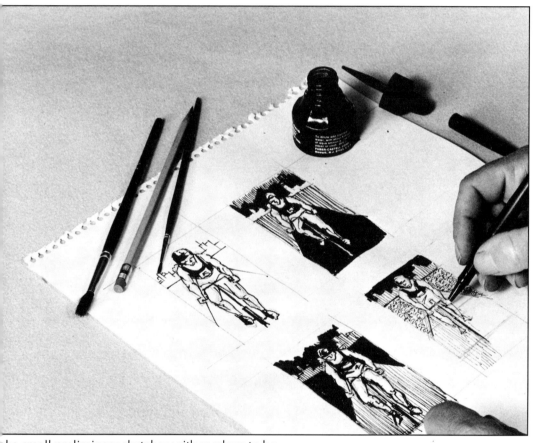

ake small preliminary sketches with markers to be re you have framed your subject properly and cho- n the right design approach.

APPROACHES TO DRAWING
AND TRANSFERRING

The methods of drawing and transferring you use will often be determined by the complexity of the particular drawing. As a general rule, the more complex the drawing, the more thoroughly it should be drawn or transferred onto the block. Sometimes the method you use will be dictated by your equipment or the materials available to you.

People vary widely in their ability to visualize in black and white. Some can envisage where the black and the white areas will be by looking at a simple outline drawing. Others need a complete, detailed drawing on the block before they can begin to cut. As you gain experience, you will be able to take shortcuts. Some woodcutters develop their designs during the cutting stage. This requires considerable confidence, especially for the novice woodcutter.

The concept of reversed image often presents problems for people. The design on the block will be reversed in the printed impression. In other words, forms on the right-hand side of the block will print on the left-hand side of the paper and vice versa. As with all problems of visualization, experience usually helps. But some methods are easier for some people than others. In the final analysis, you must decide what method of drawing and transferring works best for you.

METHOD 1: DIRECT DRAWING ON THE BLOCK

MATERIALS: Drawing ink and brushes; marking pens; pencil or red Conté crayon.

Using one of your preliminary sketches as a guide, make a light outline drawing on the block in pencil or red Conté. Complete the design using black drawing ink and brush. Drawing ink will usually dry within minutes, marking pen ink almost immediately. Small details may be drawn with a marking pen. Paint out errors with gesso, white acrylic paint, or typewriter correction fluid, but take care to apply these as smoothly as possible.

Keep in mind that the image on the block will print in reverse. If you are including letters or numbers in your design, these will have to be drawn in reverse on the block. One way to accomplish this is to first write them out on a thin sheet of paper as you want them to appear in your print. Then tape the paper to a window or light table with the letters or numbers facing the light. Redraw them in reverse on the back side of the paper. Copy or trace the reverse letters or numbers onto the block.

If your ink drawing has been done on a block without a ground, you can rub the block with charcoal or Conté crayon so that cuts will contrast against the surface. Cover the surface of the block with a coat of charcoal or Conté, and then rub it with a soft cloth. Then spray the block with charcoal fixative. You can use common hairspray as a substitute for charcoal fixative. An alternate method is to use a cloth to rub oil paint into the block. The color you choose is not critical as long as it is lighter than your drawing. To control the amount of pigment applied, squeeze the paint out on an ink glass before applying it to the block. Thick paint may be thinned with paint thinner.

METHOD 2: TRACING A DRAWING ON THE BLOCK

MATERIALS: Red Conté crayon; pencil or stylus; newsprint; drawing ink; marking pens; scissors or X-Acto knife; masking tape.

The back of a drawing or sketch on paper can be covered with a layer of red Conté crayon, and then the design can be traced lightly on the block using a pencil or stylus. (An empty ballpoint pen works well.)

Another method, similar to the above, preserves the original drawing by creating a Conté carbon copy. To do this, a sheet of newsprint is covered with red Conté crayon and then this "carbon" is placed face-down on the block. The drawing is placed on top of the carbon and then traced onto the block using a stylus. The design is completed with drawing ink and/or marking pens.

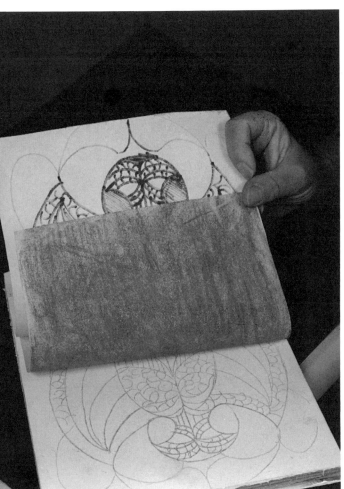

STEP 1 To make a Conté carbon, first cut a sheet of newsprint that conforms to the dimensions of your block.

STEP 2 Using the side of a red Conté crayon, cover the entire sheet of newsprint with an even coat of color.

STEP 3 Place the Conté-covered side face-down on the block followed by the drawing face-up. Secure them with masking tape.

STEP 4 Trace an outline of the design onto the block with a stylus or sharp pencil.

STEP 5 Go over the design on the block with black ink and/or marking pens.

METHOD 3: DRAWING AND TRANSFERRING WITH TRACING PAPER

MATERIALS: Tracing paper; red Conté crayon; penc[il]; drawing ink; marking pens; scissors; masking tape.

In this inexpensive method of drawing and transferring, the design is refined as it progresses through several stages, from the preliminary sketch to the finished drawing on the block. This is also a good method to use if a considerable number of letters or numbers ar[e] to be included in the composition.

STEP 1 Place a sheet of tracing paper on a white background. Make an outline of the block on the tracing paper and, using your preliminary sketch as guide, make a light pencil drawing of the composition on the tracing paper. If letters or numbers are t[o] be included, they should not be drawn in reverse o[n] the paper because they will be reversed later when the drawing is traced onto the block.

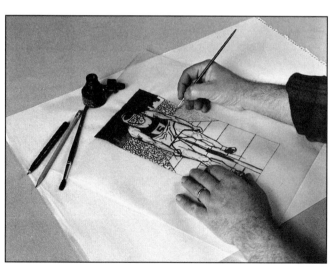

STEP 2 Complete the drawing with brush and ink. Use a marking pen to draw smaller areas of detail. You can make changes or corrections on the tracin[g] paper with gesso, white acrylic paint, or typewriter correction fluid. Alterations can also be made later when the composition is refined on the block.

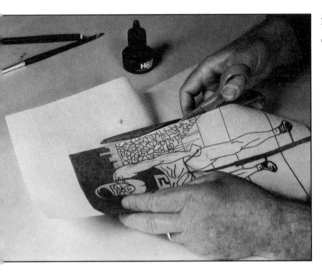

STEP 3 Cut out the drawing, following the outline of the block on the tracing paper.

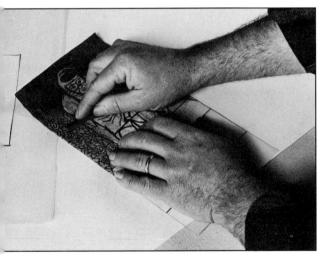

STEP 4 Completely cover the face of the drawing with red Conté crayon.

STEP 5 Place the tracing paper on the block with the Conté-side down. Tape the paper to the block t hold it in place. Outline the back of the drawing with a stylus or pencil. Do not press too hard or yo will engrave the block, causing white lines to appear in the printed impression.

STEP 6 Complete the design on the block with black ink and marking pen, taking care not to lose any of the spontaneity from the original drawing. Spray lightly with fixative or hold a piece of paper under your hand while drawing to keep the Conté from smudging. Areas within the design that will contain textures can be left as whites.

ETHOD 4: DRAWING AND TRANSFERRING ITH CHARCOAL

MATERIALS: Tracing paper; charcoal pencil; scissors; spoon; masking tape.

ansferring a charcoal drawing directly to the block one of the faster methods of developing a woodcut. this method a charcoal drawing is placed face- wn on a wood block and the drawing transferred burnishing with a spoon. A charcoal pencil can be aped or sharpened to produce either a bold or a

detailed drawing. It is most important that the charcoal be applied fairly heavily, and it is also important that the drawing have characteristics similar to one executed with a brush or felt-tip marker. Red or brown Conté crayon can also be transferred in much the same manner as charcoal.

STEP 1 Using a charcoal pencil, make a drawing on tracing paper that corresponds to the dimensions of your block.

STEP 2 Place the drawing face-down on the block. Secure it with a few pieces of masking tape.

STEP 3 Rub the back of the paper with a spoon. Turn a corner back to see if the drawing is transferring satisfactorily.

STEP 4 After the drawing has been transferred, spray the block with a light coat of fixative to keep the charcoal from smudging. You may have to refine and strengthen the image with black ink.

METHOD 5: PHOTOCOPY TRANSFER

MATERIALS: Black-and-white drawing; lacquer thinner (solvent); 2-inch brush and glass jar or latex gloves; cotton cloth.

A black-and-white drawing can be photocopied and the image from the copy transferred to the block with lacquer thinner. (Acetone also works, but because of its extreme flammability, it is not recommended.) Photocopy transfer is good for detailed drawings because the image on the block will be an exact replica of the original drawing, but an image in reverse. The darker the photocopy, the darker the drawing on the block. Both gesso-ground and no-ground blocks will accept a photocopy transfer.

An additional benefit of photocopy is that you can reduce or enlarge a drawing. However, a copy made from a copy (as is sometimes required by the process of changing the size of a drawing) may not be as true to detail as a copy made from the original. The photocopy should be the same size as the block. Drawings that are too large for a copy machine can be cut into sections. Copy each section

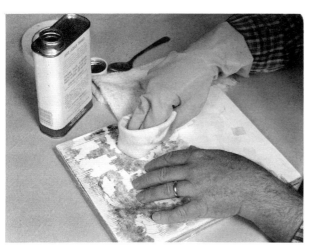

STEP 1 *BRUSH APPLICATION:* First place the photocopy face-down on the block, and secure it with masking tape. Then pour about ½-inch of lacquer thinner in a jar. Dip the tip of a brush in the solvent and draw it across the lip of the jar several times. Push the brush in a cotton rag to remove any excess fluid. Too much solvent can dissolve the gesso or cause the toner to bleed. Begin at one corner and brush one 2- to 3-inch square section of thinner on the back of the photocopy.

STEP 1A *CLOTH APPLICATION:* Here, the lacquer thinner is applied wearing a latex glove and using a cotton cloth dipped in lacquer thinner. Once the cloth is dampened with the thinner, rub the thinner on to the back of the photocopy in small sections at a time.

dividually, j94

en reassemble the drawing. A few pieces of mask-
g tape or transparent tape can be used to hold the
ctions together.

ransfer the photocopy to the block by placing it
ce-down on the block and then paint or rub the
ck with lacquer thinner. The lacquer thinner releas-
the toner, which is what makes the impression on
e copy. When the photocopy is burnished with a

spoon, the image adheres to the block.

Wear a latex glove if you rub the thinner on the
block with a cloth. It is a good idea to experiment
with both methods of application on a separate wood
block, mat board, or illustration board to see which
one works for you.

Because the fumes emitted by lacquer thinner are
dangerous, work in a well-ventilated, unpopulated
area. Lacquer thinner poses some hazards, so read

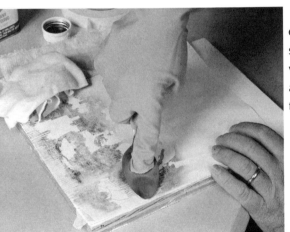

STEP 2 Working quickly, before the lacquer thinner
evaporates, burnish the wet portion of the transfer with a
spoon. Turn back a corner of the photocopy to see how
well the image has transferred. It may be necessary to lift
a portion of the photocopy after each burnishing so that
the photocopy does not adhere to the gesso.

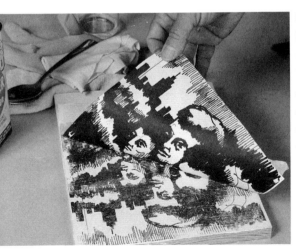

STEP 3 Work across the block, applying the solvent and
burnishing one section of the transfer at a time. You may
repeat this procedure to strengthen the image on the
block, but you must allow the photocopy to dry thor-
oughly before applying more solvent. Do not apply lac-
quer thinner to the masking tape. Remove the tape to a
dried portion of the transfer. After you complete the
transfer, you can touch up the image on the block with
drawing ink or a marking pen.

CUTTING THE BLOCK

ow that you have prepared the block and transferred your drawing to it, you e ready to cut the block. There is no set le on where to begin to cut, but if this is ur first woodcut it might be a good idea to in confidence by beginning in an area that not critical to the design. For instance, if ur design is representational, begin cutting e background area. I prefer to cut out small eas of detail first, and then larger ones.

Some beginners prefer to practice with all e tools, cutting first on a separate block. It a good idea to have a practice block of the pe of wood you intend to use handy for the rpose of testing your tools for sharpness.

When you cut never place your free hand front of the cutting tip. If the tool slips you can be seriously injured. Instead, push the tool with one hand and guide it with the other; keep both hands away from the tip.

Sometimes a block will slip on the table while you are cutting; in this case, it may be necessary to use a bench hook to hold the block in place. The construction of a bench hook is discussed later in this chapter.

If you begin cutting and the wood tends to split, rub a bit of linseed oil into the wood. Pour a small quantity of oil on the block and rub it in with a soft cloth. Be sure the entire surface is covered. Allow a few minutes for the oil to soak in before cutting. When cutting into plywood, splitting problems can be remedied by simply turning the block and cutting from the opposite direction.

The correct cutting position for the gouges: one hand pushes while the other guides the tool.

A bench hook will keep the block from slipping. This bench hook was made from a discarded section of house siding and a 1- x- 2″ (2.5 x 5.0 cm) furring strip.

THE WOODCUT KNIFE

The primary function of the knife is to remove precise, sharply defined areas from the block. Keep the knife tilted at a 45-degree angle and excavate the wood by making a series of encompassing incisions. It may be necessary to chip an area out after the incisions are complete, especially when you are cutting into plywood. The type of knife you use is largely a matter of personal preference. A double-beveled knife will allow you to cut into a block from opposite directions by tilting the tool from one side to the other.

When cutting with single-beveled knives, make sure the flat side of the tool faces the area to be cut. You will discover that whatever type of tool used, it is easier to reposition the block than to try to redirect the tool.

The knife will produce engraved or scratched effects if it is held perpendicular to the block and drawn across it with considerable pressure. Also, in small sets of tools, the knife is intended to perform the function of chisel, which is used primarily to shave off ridges left by the gouges.

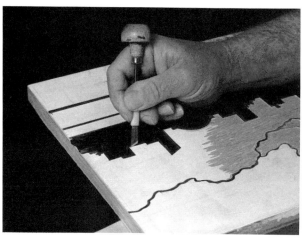

Three cutting positions for the knife. Note the tape around the shank of the tool to keep it from cutting into the fingers.

THE U-GOUGE

Generally, the sharper, deeper, and more narrow the scoop, the larger the stroke you can make. Of all the tools, the U-gouge is the most versatile. If properly honed it will cut with exceptional ease both along and across the grain.

The deeply scooped and wide-mouthed U-gouge works well for cutting curved lines around irregular shapes and small details. It is able to glide through wood in a continuous motion, but in the case of very hard or grainy woods, you need to rock the tool slightly from side to side while pushing it forward slowly. The U-gouge will also produce long straight cuts if you run it along the edge of a metal rule. As with all gouges, the tip of the tool is raised at the end of each stroke.

Japanese tool sets seldom contain a deeply scooped U-gouge. European and American sets usually do. My advice is to check the contents before purchasing any tool set. If you have a set of tools that does not contain a U-gouge, then use a small C-gouge to perform similar tasks.

Cutting with a U-gouge. This gouge is the most versatile. It can be used to cut straight and curved lines and small details. It will cut wood easily both along and across the grain.

THE C-GOUGE

C-gouge cutting techniques will vary for the smaller C-gouges (numbers 1 through 3) depending on the sharpness of the tool and the depth and width of the scoop. Practice on a separate block of wood to learn the limits and possibilities of this tool. Cut both curved and straight lines. To cut curves, tilt the tool at a slight angle toward you, then stroke in an arcing motion. Raise the tip a little at the end of each stroke.

Larger C-gouges, no. 4 and higher, are designed to remove broad areas of wood from the block. The wider the C-gouge, the greater the wood resistance encountered in cutting. Because of this resistance some woodcutters find it less work to remove a large area of wood with a narrow C-gouge rather than a wide one, especially when cutting across the grain.

To remove broad areas of wood with the C-gouge, begin at one side and work across the block, laying each stroke as closely to the last as possible. This technique will leave rib-like patterns on the block. These may be shaved off with a knife or chisel or left on the block. The rib-like texture may actually add interest to the print. Try a test print before you cut the texture out; you may like it.

Cutting with a C-gouge. This tool has less of a scoop than the U-gouge; it can be used to remove broad areas of wood.

THE V-GOUGE

The V-gouge will produce thin tapered cuts. If properly sharpened, it will remove small angular details. The tip of the tool should be slightly raised after each stroke to keep a sliver from forming at the end. The V-gouge can also begin a cut in an area that requires a sharp angle or corner; what is left may then be removed with the wider gouges.

Cutting with a V-gouge. This tool can be used to cut sharp angles and thin tapered cuts.

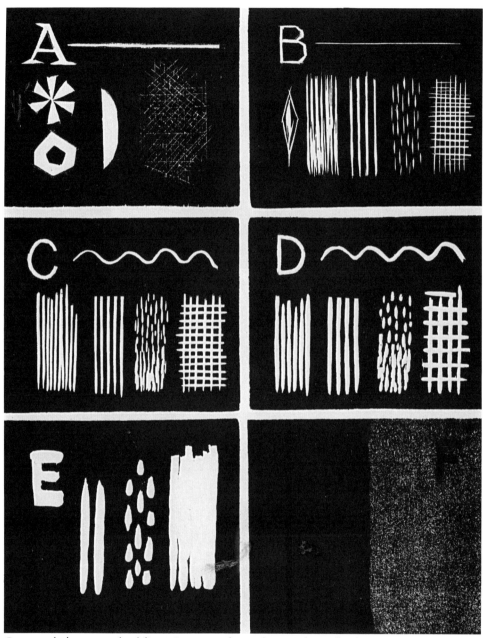

Cuts made by a standard five-piece set of woodcut tools: **A** knife; **B** no. 4 V-gouge; **C** no. 2 U-gouge; **D** no. 6 C-gouge; **E** no. 8 C-gouge; **F** an uncut block printed on the left with a metal tablespoon, using moderate pressure; on the right, with a wooden spoon, using light pressure.

MAKING INCISIONS BEFORE CUTTING

Before cutting, scoring the block with an X-Acto knife can prevent cuts from extending beyond their intended limits. Make incisions along the borders of any large areas you intend to remove. Until you become comfortable handling the various tools, it may be advantageous to score much of the woodblock.

STEP 1 Incising the block with an X-Acto knife before cutting will reduce errors. To score straight-edge shapes, run the knife along the length of a metal yardstick.

STEP 2 If properly scored, the wood will break away cleanly from the block at the point where the cut and the incision meet.

DEPTH OF CUTS

Cuts made with the gouges need not be so deep that the tips of the tools become buried, or, in the case of plywood, that the second layer of veneer is exposed. However, cuts must be of sufficient depth that they do not pick up ink from the brayer when the block is rolled up. Broad recessed areas of about 3/4-inch or more may collect ink regardless of how carefully a block is rolled up. In such cases the block may have to be cut more deeply than normal, or it may be more expedient to simply mask out the area with paper or masking tape after each roll-up.

This is the block from which the black-line woodcut from chapter 2 was printed. The cuts were varied in depth according to how much texture the printmaker wanted to show in the impression. The darker areas of the block are cut deeper. They print as pure whites in the impression.

USING A MASK-OUT

Large areas of wood on the perimeter of or within a block need not always be cut away entirely. A *mask-out*, which is a type of stencil, can be used to cover portions of a rolled-up block before it is printed. The masked-out or covered portions of the block will keep ink from transferring to the print papers. After a block has been printed, the mask-out is removed. The inking and masking-out procedure is repeated for each print made. A simple way to make a mask-out is to pull a quick impression on newsprint, and then cut out the mask-out portions with scissors or an X-Acto knife.

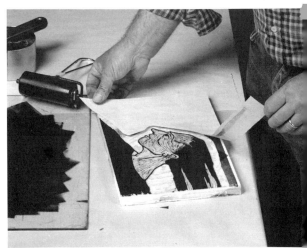

Some areas of a woodblock need not always be cut away. Only a narrow area of wood was cut away immediately adjacent to the profile of the figure. A mask-out is used to cover uncut portions of the block that inadvertently picked up ink from the brayer. The mask-out will keep unwanted ink deposits from transferring to the print paper.

REPAIRING MISTAKES

The novice woodcutter can anticipate making a few cutting errors. In most cases, an error can be repaired by finding the wood chip that broke off and glueing it back in place with carpenter's glue. This is generally the easiest repair method. Occasionally, you may find it necessary to use wood filler or to make a wooden plug.

REPAIRS WITH WOOD FILLER

Wood filler can be used to fill holes, dents, and small cut-out areas. Wood that has been inked but not cleaned with paint thinner can usually be filled. But, if at all possible, repairs with filler should be made in advance of printing, because the filler may not hold once the block has come in contact with paint thinner. Sometimes the filler will bond if an extra bit of wood is trimmed from the surface of the area, exposing fresh wood for bonding.

Using a dry cloth, wipe as much ink from the block as possible. Fill the hollow, then wipe away any residue from the surrounding area. Allow the filler to dry thoroughly before sanding and then redrawing the design.

It is not advisable to use wood filler if a block will be subjected to heavy and repeated spoon printings.

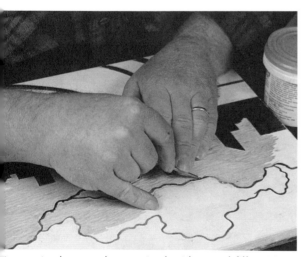

Minor mistakes can be repaired with wood filler. Use a palette knife to fill in the affected area. Clean away any excess filler from the surrounding wood and allow the filler to dry. You may need to add more filler if the first application shrinks.

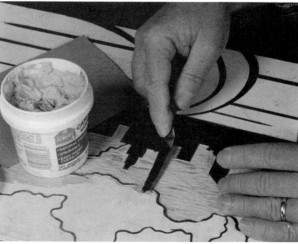

After the filler dries, sand it to the level of the surrounding area. Redraw the design and proceed to cut.

If a block requires major restoration, or if a large edition is to be printed, then the best repair method is the insertion of a wooden plug. A plug may also be needed on a block that has been printed and cleaned with paint thinner. Repairing this way is worth the effor

MATERIALS: Small pine block to cut plug from; X-Acto knife; U-gouge; glue; wood filler; utility hacksaw; sandpaper; knife.

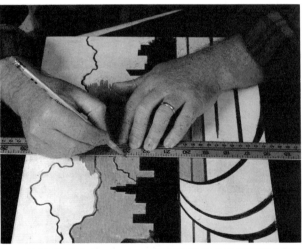

STEP 1 Measure and mark the area that is to be replaced by the repair plug.

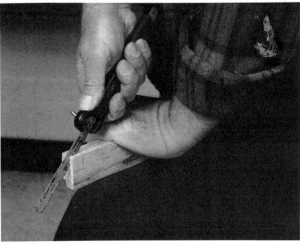

STEP 2 Draw the dimensions for the plug on the repair block: length, width, and thickness. When cutting out the plug, make the first cut along the length of the board, as shown here.

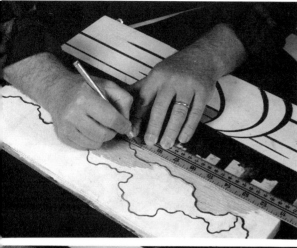

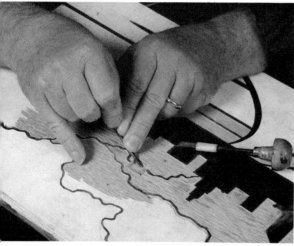

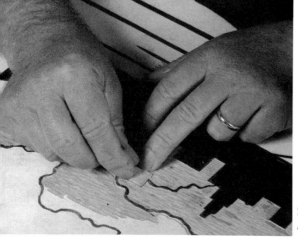

STEP 3 Place the plug over the area to be replaced and make an outline of it in pencil. Using an X-Acto knife, deeply score the block along the pencil lines.

STEP 4 Using a small U-gouge or C-gouge, excavate the plug area, cutting to the depth of the incisions. Repeat the scoring and cutting procedure until you achieve the desired depth.

STEP 5 Glue the plug in place with wood glue.

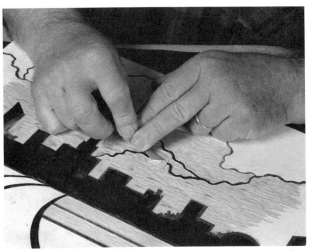

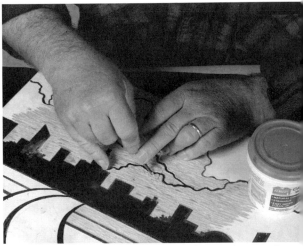

STEP 6 After the glue has dried, carve the plug to the height of the surrounding relief areas. If a plug is more than ⅛-inch (.32 cm) higher than the block, it may be best to saw it off with the utility hacksaw blade. Any gaps or seams surrounding the plug can be filled with wood filler. Use your finger to force filler into the seams. Wipe off excess filler and allow the remainder to dry. Sand the block smooth.

STEP 7 Draw the design on the plug with a marking pen, and then proceed to cut.

REPAIRING HOLES IN PLYWOOD

Sometimes when you cut into plywood the surface will cave in because of a hollow spot under the veneer. There are three methods for repairing this cave-in, and any one of them can work depending on the extent of the damage.

METHOD 1 Clear away enough wood so that filler can be forced into the cavity beneath the remaining veneer. Allow the filler to dry for several hours, then fill the remaining hole.

METHOD 2 Cut away the veneer covering the hollow, exposing the entire cavity. Fill the cavity with wood filler, allow it to dry, then sand it smooth. Redraw the design and proceed to cut.

METHOD 3 Remove the veneer to expose the entire cavity. Plug the hole with a wooden plug.

REMOVING LARGE AREAS
OF SOLID WOOD

Cutting out big areas of solid wood is best accomplished with larger carving or sculpture tools. The block will have to be supported by a corner bench hook or fixed to the table with one or two C-clamps. If you use C-clamps, place a small square or two of cardboard between the clamp and the block to protect the wood.

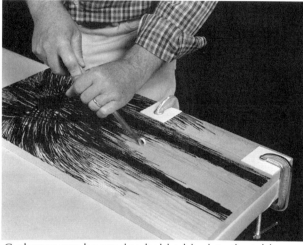

C-clamps can be used to hold a block to the table. Small squares of cardboard under the clamps keep them from denting the wood.

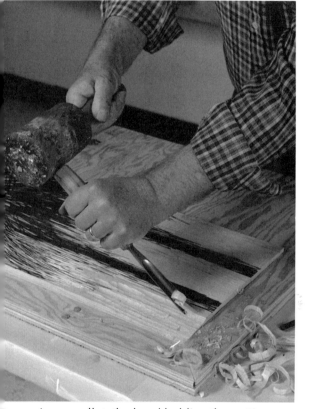

When using a mallet, the hand holding the cutting tool controls both the direction and the depth of the cut. The corner bench hook used here is positioned at the right-hand corner of the table. Turn it over and place it at the left-hand corner for left-hand cutting.

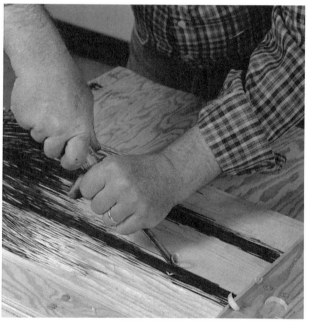

Cutting a block with large carving tools can often be accomplished without the aid of a mallet. One hand forces the tip through the wood while the other guides the tool and regulates the depth of the cut. A chisel or shallow C-gouge can be used to shave off ridges left by the deeper gouges.

REMOVING LARGE AREAS
FROM PLYWOOD

Plywood consists of thin layers of wood glued together with the grain running in different directions. The only effective way to remove large portions is by systematically removing one or two layers at a time.

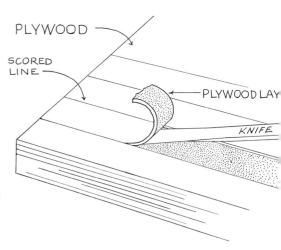

PLYWOOD

SCORED LINE

PLYWOOD LAY

KNIFE

The best method of removing large areas of plywood is to split the wood from the block in layers. Score the block in ½-inch (1.3 cm) strips using a utilty knife or an X-Acto knife. Force the knife or chisel into the wood, and then slowly push forward while slightly rocking the tool from side to side. Repeat the procedure until you achieve the depth desired.

CONSTRUCTING BENCH HOOKS

A bench hook supports the block during the cutting. It should be compatible in size with the woodblocks you intend to cut. A corner bench hook can be made to support larger blocks. Take care not to make a bench hook so large that when it is put into place you cannot reach your block.

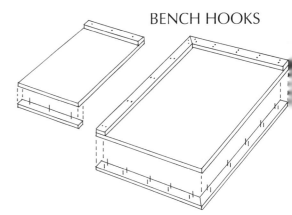

BENCH HOOKS

The construction of two types of bench hooks: The corne bench hook to the right is for cutting large blocks with large carving or sculpture tools. The corners of the supporting strips do not have to be mitered provided they a squared before being secured. The strips should be glue as well as nailed or screwed to the board.

These three bench hooks were made from a ¼-inch (.64 cm) sheet of ½-inch (1.3 cm) plywood. This size was selected so the supporting strips will be lower than the ¾-inch blocks used for woodcuts. This prevents the strips from being cut along with the woodblock.

NONTRADITIONAL TREATMENT OF A BLOCK

You can achieve a variety of unusual effects by pounding a block with hardware and household utensils. Experiment on a trial block of wood to determine what objects will reproduce effectively. However, be aware that pounding too hard can dent or split the wood.

An electric engraver or woodburning tool can also be used to create interesting patterns and textures.

These demonstation prints were pulled from four small blocks embedded with patterns from a variety of hardware and household utensils: **A** nails and nail holes; **B** screwdriver tips, putty knife, nuts, corrugated fasteners, screw and screw eye; **C** sewing pattern wheel; **D** wire brush.

PRINTING THE BLOCK

When you have completed cutting your block, you are ready to print. First gather all the materials you will need: newsprint for proofing and printing papers for editioning; yardstick; scissors; pencil; ink; roll-up glass; putty knife (ink knife); brayers; toothbrush and cloth to clean off your wood block; paint thinner; clean-up rags. Printing inks are quite permanent, so it might be a good idea to wear an apron or smock.

CUTTING THE PRINT PAPERS

Print papers should be cut at least 1½-inches (3.8 cm) larger than the block to provide sufficient border for matting. Papers can be measured and marked using a yardstick and pencil. Rice paper should be cut with a scissor; it tends to shred if cut with an X-Acto knife. The number of prints you decide to make is up to you, but I recommend an edition of at least six to ten impressions for the beginning printer.

PREPARING THE BLOCK FOR PRINTING

To prepare the block for printing, brush woodchips and dust from the recessed areas of the block (a toothbrush works well for this purpose). Wipe the entire block clean with a cloth. Then run a hand lightly over the surface and feel for slivers that may be present at the ends of cuts. These are the result of incorrect cutting and can be removed by carefully cutting in from the direction opposite to the original cuts.

If the block has not been treated with paint thinner or linseed oil, pour a small quantity of thinner on the block and rub it in. Wipe the block as dry as possible and let it set a few minutes. This treatment will lessen the absorption of ink into the block.

PROOFING THE BLOCK

It is a good idea to pull an inexpensive newsprint proof before printing on the expensive edition papers. A proof may reveal that additional cutting on the block is necessary. If you wish to make further alterations to the block, clean it with paint thinner before you cut. You can also use small pieces of newsprint to cover portions of the proof to determine where additional cutting is needed before actually cutting.

SELECTING THE BRAYER

A 6-inch (15.2 cm) brayer will work for most woodcuts. When printing blocks with small or narrow areas of relief, roll up with a 2–inch brayer or smaller to keep ink from collecting in the broad recessed portions of the block.

TOUCHING UP PRINTS

Most professional block printers consider it unethical to touch up prints for the purpose of covering up mistakes made in cutting and printing. Occasionally, you will discover minor mistakes or imperfections after an edition is complete. In some cases, a few minor mistakes made while cutting do not warrant major repair work to the block. I personally see no reason why beginning printmakers should not have the opportunity to improve their impressions, providing that minor imperfections can be touched up to match the surrounding areas.

There are two methods of touching up prints, the first involves using a ballpoint pen and the other using printing ink. Black ink from a ballpoint pen will not bleed. It works best for filling in broken lines. The ink should flow readily from the pen with little pressure applied to the paper. Fill in an area by lightly working the pen back and forth.

If you use a brush and printing ink, the ink will probably have to be thinned with paint thinner. It should be thinned to the point where it barely flows from the brush when applied to the paper. If the ink is too thin it will bleed excessively, or not appear dark enough on the touch-up area. If it is too thick, it will flow smoothly from the tip of the brush, thus causing this painted area to appear ragged or rough. This method works best when touching up broad areas of black; the ink may bleed if used to fill in broken lines. After applying the ink to the print, immediately blot the area with newsprint or paper towel.

DRYING PRINTS

The drying times of inks will vary depending on the manufacturer, temperature, and humidity. Most inks will take several days to dry. Heavily inked prints can be blotted with newsprint to hasten the drying process, as well as to enhance the surface quality of the impression. To blot a print, place a clean sheet of newsprint on top of the impression, and then rub the back thoroughly with the heel of your hand. Take care not to move the blotting paper once it is on the print or you may smudge the image. Remove the paper carefully.

Do not place completed prints on top of each other unless they are completely dry. If woodcuts must be transported wet, they can be placed in between sheets of newsprint. A newsprint pad works well for this purpose. The prints will stick to the newsprint only if they were printed with too much ink. Wet prints can be placed on a drying rack or hung with clips or clothespins.

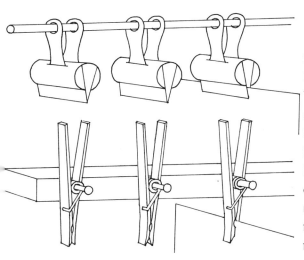

Spring clips or clothespins can be used to suspend drying prints. There are various types of clips available with holes at the top. In the top illustration a dowel is inserted through the spring clips. In the bottom illustration clothespins are nailed to a furring strip. Either of these can be fixed to a stand or suspended from the ceiling.

CLEAN–UP

Using cardboard, or a metal scraper, and paper towels, scrape up the ink left on the ink glass and discard it. The ink glass can be cleaned with paint thinner or alcohol. Alcohol makes much less of a mess because the ink is picked up on the cleaning rag in coagulate form, rather than dissolved form as is the case with paint thinner. The brayer and holder should be cleaned with a soft cloth and paint thinner only. Clean the block with thinner if it is to be used again. If the block has not been cleaned previously and is still white in the recessed areas, it can be left to dry and framed as a wood relief.

BASIC PRINTING PROCESS

With some experience, printing a wood block is relatively simple. An even film of ink is rolled out with a brayer on a roll-up glass. The ink is transferred from the brayer onto the block. Paper is placed on the block, and the image is printed by burnishing

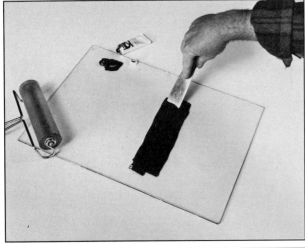

STEP 1 Place a liberal amount of ink on the corner of the ink glass. Take some ink from the pile with the putty knife and draw a flat line of ink across the glass extending the length of the brayer.

STEP 2 Roll the brayer back and forth, changing directions, until both ink glass and brayer are covered with even film of ink. The correct amount of ink should show a slight bead and make a gentle swishing sound when rolled. Highly visible beads of ink and a loud swishing sound indicates too much ink. The glass showing through the ink indicates too little.

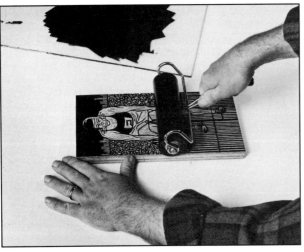

STEP 3 Roll the brayer back and forth across the block completely. Recharge it and pass it over the uninked areas. Turn the block and repeat this procedure until it covered with an even film of ink. Use a minimum of ink to preserve fine details. The first roll-up will consume a considerable amount of ink because some of it is absorbed by the wood; by now it may be necessary to add ink to the glass.

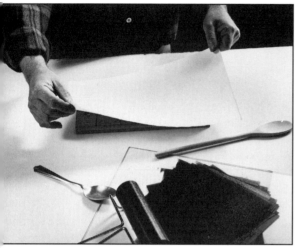

STEP 4 Hold the print paper at opposite corners, position it above the block, and lower it straight down. Make sure your hands are clean and dry, then rub the paper gently so that it adheres to the block.

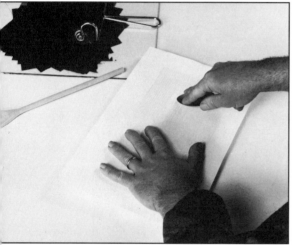

STEP 5 Hold the paper in place with one hand while rubbing the spoon across the block area with the other. It will require some pressure to transfer the ink to the paper. A corner of a print paper can be turned back at any time to check the design. Use a moderate, systematic approach to burnishing. Burnishing over the edges or corners of the block, however, can tear the paper. To print crisp edges, run the spoon along the edge of the block.

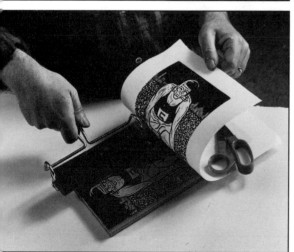

STEP 6 To re-ink the block, hold one half of the paper firmly to the block with your hand, then roll the other half back with your other hand, exposing a little more than half of the block. Recharge the brayer and re-ink the block. Do not let the brayer come in contact with the paper. Roll the paper back down on the block and rub it lightly. Repeat to re-ink the other half. Burnish the print to the desired tone. The block should not have to be cleaned unless the details fill in, the ink stiffens during a lengthy printing time, or the block collects fibers from the papers.

CHAPTER
8

SPECIAL RELIEF

TECHNIQUES

pecial relief techniques include printing from gesso, printing from modeling ıste, making cardboard relief, and using col-ge materials. They can be used indepen-ently or in conjunction with traditionally ıt blocks. If you use any of these tech-ıques, you will find that they create an addi-ınal layer of relief. When the block is rolled ɔ, the area immediately adjacent to the col-

lage or added textures will not pick up ink. This causes *haloing* in the impression; a ring of light will form around each area of collage. Haloing will also occur with textures of gesso and modeling paste. Generally, you can con-trol haloing somewhat by inking as closely to the collage area as possible and then using the tip of a metal spoon to burnish along the edges of the material.

RINTING FROM GESSO

extures can be brushed, drawn, or pressed into a heavy coat of wet gesso achieve different effects. Surfaces that are ɔugh can be sanded after the gesso dries.

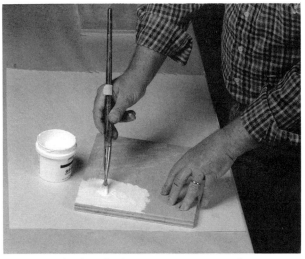

Gesso can be brushed to create a variety of patterns and textures. First apply a heavy coat of gesso to the block, and then manipulate the brush in various ways to create brushed or stippled effects.

ɪis demonstration print was taken from a circular ece of cardboard glued to a woodblock. The entire ɔck was rolled with ink. A white ring or halo sur-ɪunds the circle because the area immediately adja-ɪnt to the cardboard could not pick up ink from the ɪayer due to the thickness of the cardboard. Halo ɪects should be taken into account when designing ɔodcuts that will contain areas of collage.

PRINTING FROM MODELING PASTE

Because of its thick body and pliability, modeling paste can be used to create a wide variety of forms, patterns, and textures. It can be applied directly with a palette knife and shaped, carved, or sanded. You can press materials into the wet paste, such as heavy fabrics, mesh screen or any objects that contain areas of relief. Stencils cut from heavy cardboard can also be used. Apply the paste through the open areas with a palette knife. After the relief surface has dried it can be sanded smooth.

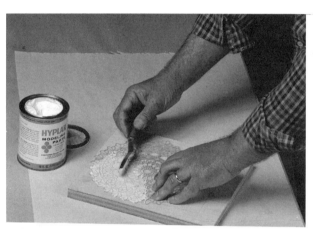

Modeling paste can produce a wide variety of textures and patterns. In these illustrations, the paste is applied through a plastic doily with a palette knife. After the paste dries it is sanded smooth with a sheet of sandpaper wrapped around a block of wood.

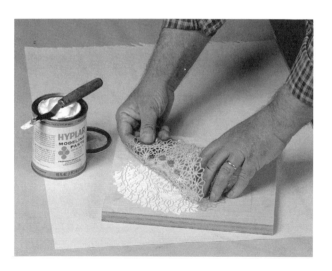

Textures and patterns printed from g and modeling paste: **A** brushed ges **B** burlap pressed into wet gesso; **C** sponge pressed into modeling paste bottom, modeling paste patterns app with a palette knife; **D** modeling pa applied through a doily with a palet knife.

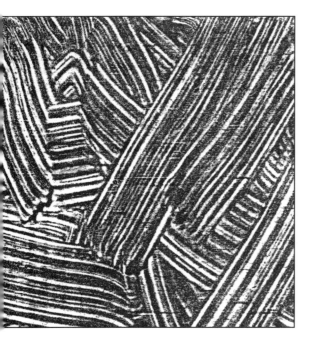

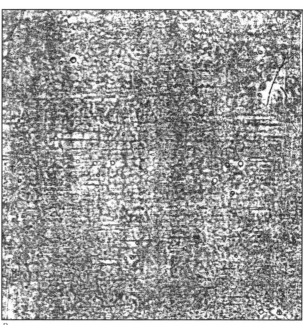

B

D

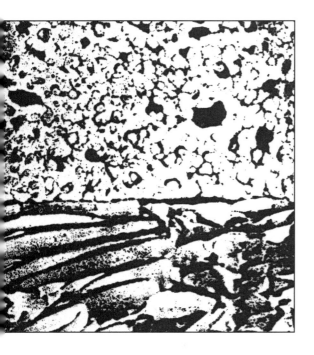

COLLAGE RELIEF PRINTING

Found objects such as cloth, string, paper, or nylon mesh can create collage effects. The objects are cut to the desired shape and then glued to the block with white glue.

Materials should be weighted and allowed to dry thoroughly. Seal absorbent materials with spray lacquer, acrylic gloss, or mat media to keep them from absorbing ink and paint thinner. Crumpled rice paper can be painted with glue or gesso and placed on the block. Immediately apply another coat of glue or gesso to cement the paper in place.

Roll up collage materials, especially fabrics, with a minimum amount of pressure so that ink does not fill in the recessed portions of the material. Burnish fabrics as lightly as possible to preserve their texture.

When printing from such rough surfaces as sandpaper, place a sheet of newsprint on top of the print paper before burnishing the block. This will protect both the print paper and the burnishing tool from damage.

Use contact cement to bond metallic materials to the block. After the material has been cemented to the block it should be rubbed or pounded thoroughly to ensure a tight bond.

B

C

ʼbove and below are impressions pulled from found objects: **A** tarlatan fabric; **B** window screen; **C** fine and ʼarse sandpaper; **D** crumpled aluminum foil; **E** White glue and string; **F** crumpled rice paper.

E

F

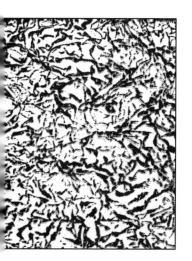

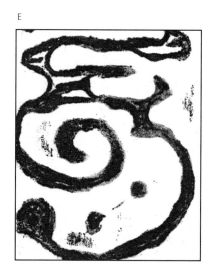

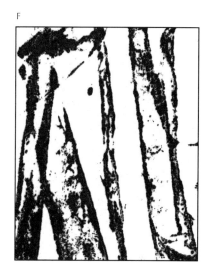

CARDBOARD RELIEF

For many years printmakers have realized the value of using cardboard to create shapes and textures. Cardboard is also a simple means of interjecting color into prints.

Cardboard relief can be used in conjunction with woodcut. White areas within an impression can be altered by printing from a simple piece of cardboard. Cut out a section of cardboard that conforms to a white area within the print that you wish to cover. The cardboard can be rolled up with either black or colored ink. To print, place the inked cardboard facedown over the white portion of the impression. Carefully slide the paper with the cardboard on it to the edge of the table, holding the cardboard in place. Once the cardboard slightly overlaps the edge of the table, release the hand holding the paper and help support the cardboard from underneath. Carefully turn the paper over while continuing to support the cardboard on both sides. To print, burnish the cardboard area under the paper with a spoon. Textural areas can be created by using such textured mat board as pebble board.

You can also print simple designs using cardboard alone. Using an X-Acto or utility knife, cut shapes from illustration board, pebble board, or museum board, and then glue them to a sheet of heavy cardboard or Masonite. You need a very sharp blade to cut through the layers of cardboard. After you have cut out the pieces, sand the edges to remove irregularities. Because cardboard relief is very low, you may have to roll it up with a 2-inch (5.1 cm) or 4-inch (10.2 cm) brayer to keep ink from collecting on the recessed areas of the plate. Even then, it may be necessary to mask out portions of the plate. Only light pressure is needed to burnish a print with a wooden spoon. The cardboard relief can be cleaned of ink by lightly wiping the surface with a soft cloth dampened with paint thinner.

The cut-out shapes can be arranged, outlined in pencil, and then glued in place. Using rubber cement will allow you to move the cardboard if necessary.

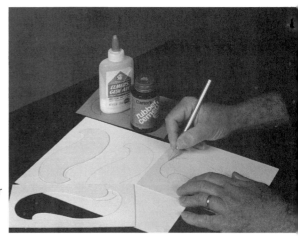

Impressions made from three types of cardboard, from left to right: linen mat board; pebble board; illustration board.

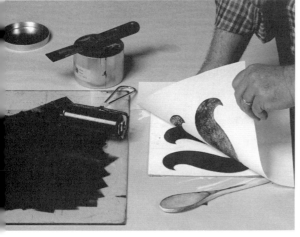

The cardboard shapes are printed as dark silhouettes on a light background, or as positive forms. The same shapes can also be shown as light silhouettes on a dark background, or as negative forms, by printing the cardboard from which the shapes were cut.

COMMON

PRINTING

PROBLEMS

Properly printed woodcuts should have evenness of tone throughout the impression. Imperfections showing in printed areas can detract from the design and degrade the over-all quality of the impression. The problems and solutions outlined below are those that most commonly occur when printing. The more experience you gain in printing, the more you will be able to anticipate possible problems before they develop.

PROBLEM: Ink does not roll up evenly on the ink glass or woodblock although roll-up has been thorough.
SOLUTION: The brayer may be concave. Pass the inked brayer across a clean sheet of paper. If the line of ink has a light streak through the center, the brayer is concave. Change brayers, or, if this is not possible, apply more pressure when rolling up, and continually move the brayer about on both glass and block.

PROBLEM: Brayer slides while rolling up ink.
SOLUTION: Check the brayer to see if it rotates freely in the handle. Adjust or clean the handle. If this does not solve the problem, scrape up as much ink as possible from the glass and place it to one side in a pile. Work in about a quarter of an equivalent amount of transparent base, transparent white, or extender. Clean off the block and proceed to print.

PROBLEM: Paper slips on the block during burnishing.
SOLUTION: Hold the paper more securely to the block, or add more ink. If this does not correct the problem, add some transparent base to the ink. In some cases, the problem cannot be corrected because there is not enough surface area covered with ink to hold the paper to the block. Then you may have to construct a paper support.

PROBLEM: Paper tears during burnishing
SOLUTION: Check for sharp or foreign objects on the burnishing tool, block, ink glass, brayer, and print papers. Check the print papers for water spots; let them dry before using the paper. If neither of the previous apply, alter your method of burnishing.

PROBLEM: Small black spots with white rings appear in printed areas.
SOLUTION: There are wood chips on the block, brayer, or ink glass. If there are just a few, pick them off. If there are many, you will have to clean up and start the inking process again.

PROBLEM: Dark blotches appear in printed areas.
SOLUTION: Check your hands to make sure they are not damp or oily. Check the print papers for water or oil spots. Water spots can be left to dry. Oily papers must be replaced.

PROBLEM: Impression appears too light, even though the block was thoroughly rolled-up and burnished.
SOLUTION: First try pressing down a bit harder when you burnish. If this fails, use more ink.

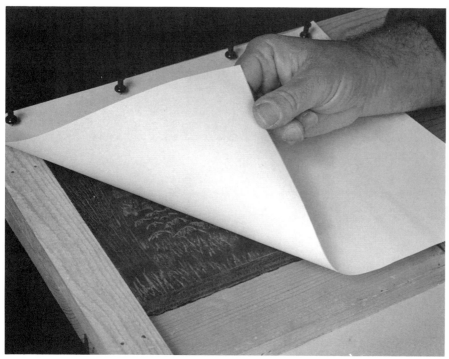

A paper-support frame will help keep print papers from slipping on the block while they are being burnished. This frame was constructed from a plywood board and two furring strips nailed to the plywood at a right angle. The block is inked and wedged against the furring strips. The print paper is placed on the block, and then secured to one of the furring strips with pushpins.

PROBLEM: Shapes and lines in the printed impression appear fuzzy, not clear and sharp.
SOLUTION: If the paper is slipping on the block, causing prints to be off register, hold the paper more firmly to the block. Or you may be using too much ink. Clean off the block. Scrape up the ink and place it to one side. Roll out the ink remaining on the brayer. This scrape and roll-up procedure may have to be repeated several times to reduce the amount of ink on the glass. You may have made cuts with dull or incorrectly sharpened tools. Sharpen the tools and run them back through the original cuts on the block. The cuts may be too shallow. Make them deeper. Do not reposition the print paper once it has been placed onto the block. When placing the paper down on the block make sure the center portion is not dragging across the block before it has been secured. Hold the print paper well above the block and lower it down straightly.

PROBLEM: Cut lines fill in and black areas are blotchy.
SOLUTION: Use less ink.

PROBLEM: The border around the impression picking up ink.

SOLUTION: Do not reposition the print paper once it has been lowered onto the block. Hold the paper well above the block and lower it straight down.

PROBLEM: Ink appears oily or too thin.

SOLUTION: Squeeze the tube until the oil is replaced by pigment. If this does not occur, replace the ink.

PROBLEM: Yellow edges on printed areas.
SOLUTION: The ink is too oily. Replace.

PROBLEM: Ink is lumpy, grainy, difficult to squeeze from the tube, or will not roll out smoothly and evenly.
SOLUTION: The ink is old, improperly mixed, or does not contain a sufficient amount of oil. Add a few drops of paint thinner to the ink and work it in. Repeat if necessary until the ink is more pliable. If this does not correct the problem, replace ink.

This illustration shows three printings from the same section of a woodblock. On the left, the block was correctly printed. In the center, the block was over-inked, and at the right, the paper slipped on the block, causing the impression to be off register.

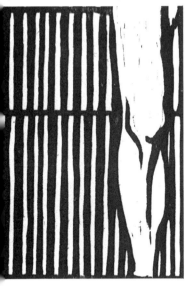
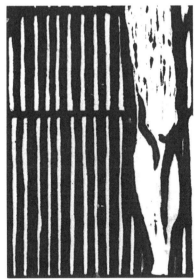

SHARPENING

AND

RESTORING

TOOLS

Nothing will discourage a printmaker faster than attempting to cut wood with dull or incorrectly sharpened tools.

You can measure the sharpness of a tool by its ability to cut across the grain of the wood. Sharpness can only be determined by testing, preferably on a block reserved for practice.

While a cut made across the grain will encounter greater resistance than a cut with the grain does, the cut across should appear as crisp as one that is made along the grain. Excessive wood resistance, coupled with jagged cutting, is an indication of a dull tool.

Sharpen exceptionally dull tools first on an oil stone, and then on an Arkansas stone for honing. Use an Arkansas stone to sharpen tools periodically during cutting as well. When working with a Tri-Stone system, use only the two smoother stones for sharpening.

Tools may require anywhere from five to twenty-five strokes to sharpen them. Although new tools normally do not require sharpening before use, I recommend pretesting them on a spare block of wood.

After sharpening tools, especially gouges, run the side of your little finger through the inside of the tips to feel for burrs. These should be removed with a slip or leather strop. To use a slip, place the stone inside the groove of the gouge, and lightly draw it through the tip. A leather strop works in much the same manner, but is drawn through the tip very briskly.

Keep sharpening stones lubricated with oil while in use, and wipe them clean with a cloth or paper towel when finished. Be sure not to sharpen in the same place on the stone repeatedly, or grooves will form in the stone.

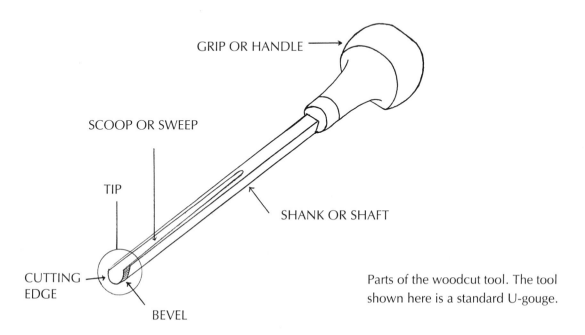

GRIP OR HANDLE

SCOOP OR SWEEP

TIP

SHANK OR SHAFT

CUTTING EDGE

BEVEL

Parts of the woodcut tool. The tool shown here is a standard U-gouge.

SHARPENING KNIVES AND CHISELS

Sharpen knives and chisels with a straight forward-and-backward stroke. Although some woodcutters use a circular motion to sharpen knives, chisels, and V-gouges, I recommend the forward–backward procedure because there is less chance of rounding the straight edges of the tools.

When sharpening knives with bevels on both sides, give an equal number of strokes to both sides of the tool. I generally move the knife foward-backward about six times, then turn it over and do the same thing. Some sets of tools contain one or two knives that are beveled on one side only. These are right- or left-handed, single-bevel tools. When a cut is made with one of these, the flat side faces the area to be cut out. Sharpen only the beveled side of these single-bevel knives.

To sharpen the knife and chisel, place a liberal quantity of 3-in-One oil on an India oil stone (do not use anything other than a lightweight engine oil). Place the bevel flush against the stone and sharpen the tool with a straight forward-and-backward motion. Hold the tool steady in a set position; do no rock it up and down. If you are sharpening a knife with bevels on two sides then give an equal number of strokes to both sides of the tool. Lighten up o the pressure during the last few strokes. If you use an Arkansas stone after the oil stone, give the tool an equal number of strokes. Test the knife for sharpness on a separate block of wood.

If burrs form on the flat edge of a single-bevel knife remove them by placing the flat side flush against the sharpening stone, and then stroke the tool lightly back and forth about two or three times.

SHARPENING THE V-GOUGE

Sharpen the V-gouge in the same manner as the knife, with straight forward-backward motion.

If a V-gouge still does not cut properly after sharpening, any number of problems can be the cause: 1. the base of the V is slightly off center; 2. one bevel was sharpened more than the other; 3. the tool was not held firmly in a fixed position when sharpened; 4. the bevels were placed at the wrong angles to the stone.

Look directly at the face of the tool. If a light spot resembling a dull reflection shows at the base of the V, then sharpen both sides of the tool. If the light area is off to one side, then concentrate sharpening on that side. The face of a correctly sharpened V-gouge should appear as a dark, perfect V.

If a tool was not held firmly in a fixed position when it was sharpened, the bevels will appear rounded. Hold the tool more securely and attempt to flatten the bevels.

If a tool must be held in an uncomfortable cutting position to work well, the bevel was cut at the wrong angle. If the V-gouge is held at an improper incline while the tool is being sharpened, a new bevel will begin to form adjacent to the original one. It is important to check the bevels of gouges when sharpening to preserve the original angle.

Sharpen the V-gouge using the same procedure as for the knife. Make sure the bevel is placed flush against the stone and apply an equal number of strokes and pressure to both sides of the tool. This is critical in sharpening this tool: An unequal number of strokes or rocking the tool will reshape the tip, rendering the cutting edge useless. If a gouge is periodically sharpened while in use, it should require only a few strokes on the stone to restore the cutting edge.

SHARPENING THE U-GOUGE
AND C-GOUGE

It is not uncommon for a gouge that has been sharpened repeatedly to develop an irregular tip with one side shorter than the other. This problem can be caused by a soft spot in the steel, but most often it is due to improper sharpening procedures—too many strokes or too much pressure applied to one side of the tool. If the irregularity interferes with a tool's cutting capability then you will have to restore the tip. First try concentrating most of the sharpening on the long side of the tip. If this does not solve the problem, then follow the tool restoration procedures outlined later in this chapter.

C-gouges have a tendency to develop burrs along the inside cutting edge. These should be removed by stroking the tools on a slip or a leather strop.

Place the bevel flush against the stone. Tilt the tool to one side, hold it steady, and stroke in a circular motion while slowly rolling it over to the other side. It should take about fifteen to twenty strokes to roll the tool over from one side to the other. Ragged cutting will result if the bottom and sides of the cutting edge are unequally sharpened. Do not sharpen the tool any more than necessary to restore the cutting edge. Two repetitions should be sufficient to hone the edge.

Whereas the other tools are sharpened with a forward-backward motion, the C-gouge is sharpened with a side to side motion. Hold the tool steady and place the bevel flush against the stone. With the other hand, place a finger or two near the tip of the tool and exert downward pressure. Simultaneously slide and rock the tool along the bevel in a motion like rocking a cradle. Slowly push the tool forward so as not to wear a groove in the sharpening stone.

RESTORING TOOL TIPS WITH AN ELECTRIC DRILL

Eventually, tools require more work than a simple sharpening; in time, they will become so worn down that the tip will need to be completely restored. One of the simplest and most economic means of restoring woodcutting tools is an ordinary electric drill fitted with a small grinding wheel attachment. A makeshift support for the drill can be created from scrap lumber. A rubber strap holds the drill to the support while wooden blocks keep it from shifting. C-clamps hold the support to the table. Some drills have a trigger lock that allows them to be operated without holding back the trigger. For drills without trigger locks an addition to the support will be necessary, such as a hole with a dowel inserted to hold back the trigger. A small buffing wheel can also be attached to the drill. An electric drill can also be fitted with a small buffing, or rouge, wheel. Two or three seconds on the buffing wheel is usually sufficient for creating a razor sharp edge.

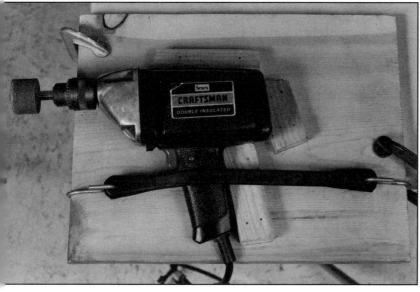

An improvised wood support to hold an electric drill steady during sharpening of tools. The drill can be fitted with either a grinding wheel or a buffing wheel.

RESTORING TOOL TIPS ON
A GRINDING WHEEL

Using a bench grinder equipped with a fine or medium-coarse grinding wheel is the most efficient means of restoring tool tips to their original condition. A grinding wheel will cut metal very rapidly, so the tip of the tool should be held against the wheel for no more than a few seconds at a time, and with a minimum amount of pressure. The tip should be dipped in water periodically to keep the steel from becoming too hot and to preserve the temper of the steel. Tool tips can be ground for longer periods of time on an electric drill because the drill revolves more slowly than a grinding wheel does.

STEP 1 Grind the tip flat and square with the shank. The tool should be held as firmly as possible with the scoop facing down. The tip should be ground only for a few seconds at a time and periodically dipped in water to preserve the temper of the steel. A tool should not be ground any more than is necessary to remove irregularities from the tip.

STEP 2 Grind the bevel or bevels. The bevels are formed by holding the tool tips at a fairly steep angle to the wheel. The procedures for forming the bevels will differ for each type of tool ground.

RESTORING THE V-GOUGE

When restoring the V-gouge on the grinding wheel, it is important to use very light pressure, especially when grinding the bevels. The sides of a V-gouge are quite thin, and it may require only two or three seconds on the wheel to create a bevel. If after several attempts you are still unsatisfied with your results, I would strongly advise restoring the tool by hand, using the sharpening stones.

STEP 1 Hold the tool scoop-side-down perpendicular to the grinding wheel with a firm, steady grip. Grind the tip flat and square with the shaft. One or two brief sessions on the wheel should do it.

STEP 2 To grind the bevels, place one side of the tip at a steep angle to the wheel. Grind one side of the tip, and then the other, until both bevels meet in the center of the tool. It is unlikely that you will be able to create a perfect V or a sharp edge. Refining the V and honing the cutting edge are best accomplished on the sharpening stones.

STEP 3 Refine the bevel and complete the sharpening process, first on the oil stone, and then on the Arkansas stone. Test the tool on a block of wood. If it must be held at too high or too low a cutting angle to the block, then the bevel must be reground and adjusted accordingly.

RESTORING THE U-GOUGE

This is the most difficult tool to restore. The grinding procedure is the same as that for the V-gouge except that the tip of the tool must be rolled over from side to center as you grind in order to form the curved bevel.

STEP 1 Flatten and square the tip using the same procedure described above for the V-gouge.

STEP 2 Place one side of the tip at a steep angle to the wheel. Begin grinding on the side and then roll the tip over to the center; immediately remove the tip from the wheel. Turn the tool over to the other side and repeat the previous procedure, again grinding from side to center. Grinding should be done quickly and with a minimum amount of pressure, especially in the center area of the tip. It is unlikely that a perfect bevel can be achieved on the grinding wheel. Refine the bevel on the smooth side of the oil stone, and hone the cutting edge on the Arkansas stone.

RESTORING THE C-GOUGE

Except for applying the bevel, the method of restoring the C-gouge is the same as described for the other gouges. To apply the bevel, line up the tip parallel to the grinding wheel and tilt it slightly to one side. Grind the bevel by slowly rolling the tool over from one side to the other, carefully following the contour of the tip.

RESTORING KNIVES AND CHISELS

The procedures for restoring knives and chisels are basically the same: Place each tool so that the cutting edge parallels the grinding wheel; grind the edge flat. Apply the bevel, or bevels, using the same procedures as described above in Steps 2 and 3 (grinding, and refining the bevels) of restoring the V-gouge.

RESTORING TOOL TIPS BY HAND

If you do not have access to an electric drill or a grinding wheel, woodcutting tools can be restored by hand with a sharpening tool called an oil stone. Of course, more time will be required for equivalent results. The procedure for restoring a tool using the stone is basically the same as the method described for the grinding wheel. The first step is to grind the tip flat and square with the shank of the tool using the course side of the oil stone.

Grinding with the coarse side of the oil stone quickly wears down tools, so it is important to complete as much of the process as possible on the stone's smooth side.

Restoring knives and chisels by hand differs little from the steps required for restoring gouges. The difference is that the cutting edges of knives and chisels are flattened by grinding in a forward-backward motion rather than in a circular one.

REFACING THE GOUGES

Except for applying bevels, the procedure for flattening the tips of gouges is the same one used for refacing or restoring all tools.

STEP 1 Apply a liberal amount of oil to the coarse side of the stone. Position the tool upright with the cutting edge perpendicular to the stone. Flatten the tip by grinding in a circular motion. Firmly hold the tool at a 90° angle to the stone and do not rock it from side to side. If you need both hands to steady the tool and grind the tip, it may be necessary to build a wood supporting frame around the stone to keep it from slipping on the table.

STEP 2 Turn the stone over, and using the smooth side of the oil stone, grind the tip once more. This wi remove the abrasions caused by the coarser stone.

STEP 3 To apply the bevel, or bevels, return to the coarser side of the stone. Place the tip at an angle yo would normally use to sharpen the tool. This angle also approximates the position the tool is held at when you are cutting on the block. After the new bevels have been ground on the coarse stone, refine them on the smooth one. Hone the cutting edges on an Arkansas stone.

RESHAPING THE V-GOUGE

It is often recommended that a V-gouge be given a raked tip (rake meaning backward slope). A rake will improve a gouge's ability to cut across the grain of the wood, especially dense hardwood.

To restore the V-gouge, you can use either an oil stone, an electric drill with a grinding wheel, or the grinding wheel method. I do not recommend raking the only V-gouge you have, because a rake will increase the width of the cut made by the tip. The greater the backward slope, the wider the cut. Too much rake will defeat the purpose of the V-gouge, which is to make narrow cuts.

To insure that a raked gouge will continue to cut narrow lines, the backward slope should not exceed that shown in the illustration. The same procedure is followed for raking a V-gouge as that for restoring a damaged one. The exception is the tip of the tool is held at a slight downward angle to the stone when the tip is flattened.

This illustration shows side views of three V-gouge tips. **A** shows a normal or standard V-gouge with the cutting edge at a right angle to the shank of the tool. **B** shows an improper angle with the point of the V in front of the cutting edge. A tip with a forward slope will rip through the wood rather than cut. With the raked V-gouge in **C,** cutting ability will be improved, but the cuts will be slightly wider than those of a normal V-gouge.

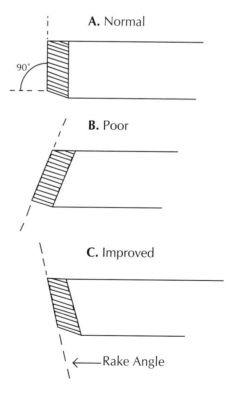

A. Normal

90°

B. Poor

C. Improved

←—Rake Angle

CHAPTER
11

PRESENTATION

Presenting prints, that is, displaying them, in a professional way following generally accepted practices for numbering, signing, matting, and framing is important. For general display or exhibition purposes, mats and frames do not have to be elaborate or expensive. Some purchasers will prefer to reframe prints according to their own tastes, and some galleries prefer to frame their own also. The methods of presentation suggested below are recommended for general display or exhibition purposes.

NUMBERING AND SIGNING PRINTS

Number and sign prints in pencil. For beginning printmakers I advise a system of numbering the edition somewhat different from that used by professional printmakers and print studios. With professionally produced prints, only those of the highest quality and consistency are retained, and the remainder destroyed. After the edition has been completed, the block is often defaced, usually with a large *X* carved through the center and a print called a cancellation proof is made from the block. This preserves the integrity of the edition and ensures that no more prints can be made. The prints are then numbered and signed by the artist.

A few, not more than 10 percent of the edition, are selected as artist's proofs. These are labeled A/P (artist proof) and become the exclusive property of the artist. They may be used for exhibition purposes, given as gifts, or sold. The remaining prints are numbered. A number designation such as 1/20 indicates that a print is the first in an edition of twenty. Since all the prints are of equal quality, the order in which they are numbered is not critical. With the novice printmaker greater latitude must be allowed in selecting prints for the numbered edition, since impressions will often vary in consistency and quality. I advise beginners to use the following procedure for numbering and signing their edition.

1. Lay all the prints out and examine them for evenness of tone, sharpness of detail, and overall neatness. Select one of good quality and label it A/P. This is your possession.

2. Count the remaining prints. If there are 10, for example, this will become the edition number. Select a print which compares favorably with the artist proof and label it 1/10. Select the next best print and label it 2/10, and so on. Print numbers, in this case, will indicate print quality.

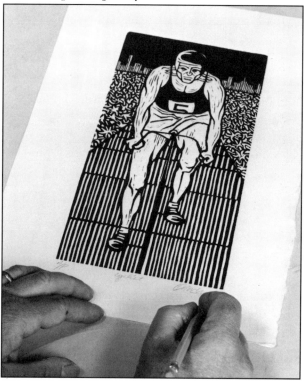

Prints should be numbered and signed in pencil. The edition numbers are traditionally at the left with the title in the center and the signature to the right.

MATTING

If you are in doubt about which color mat to use, use white. White or off-white mats or museum boards have been the standard for years; they are unobtrusive and will not compete with the print. As a general rule, a mat should be no less than 2½-inches (52 cm) wide, and no more than 4-inches (10.2 cm) on the top and sides. The bottom may be slightly wider. There should be a border between the mat and the impression, at least ¼-inch (.64 cm) on the top and sides, and ½-inch (1.3 cm) on the bottom to accommodate the signature.

It is best to construct a hinged mat. Less tape is required to hold the print in place, saving wear and tear on the paper should it be rematted at a later time. It is also much easier to align the print under the mat prior to taping it in place. A substantial white backing should be used, cut to the same outside dimensions as the mat.

Masking tape can be used for temporary mats but in time will lose its adhesiveness and discolor the print papers. White gummed linen tape is the most common tape used for permanent mats.

Beveled mats are preferable on prints intended for exhibition or for sale. Dexter, Alto's E-Z Mat, and Holdfast are moderately priced mechanical mat cutters. These come with full sets of directions, but practice is necessary to become proficient in their use.

The alternative to cutting one's own mats is to purchase precut mats or to have them prepared by a professional frame shop.

Nonbeveled mats are relatively easy to cut and require only a utility knife and a metal bar or yardstick. Most printmakers who cut their own mats prefer to use a heavy steel bar. If you cut nonbeveled mats, you can get a beveled appearance by sanding the outside edge of the mat window with fine sandpaper.

For permanent mats it is best to use acid-free, all-rag, museum board. The backing should also be acid-free. White is a must for woodcuts printed on semitransparent rice paper. The two small linen tabs allow the print to be removed from the backing simply by cutting the tape along the line where tab and backing meet.

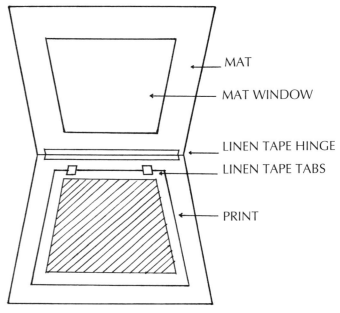

MAT

MAT WINDOW

LINEN TAPE HINGE

LINEN TAPE TABS

PRINT

CUTTING A NONBEVELED MAT

The materials you will need to cut a non-beveled mat are: mat board or museum board; backing; metal bar or yardstick; utility knife; linen tape; pencil; art gum or red eraser; fine sandpaper.

. First cut both mat and backing to the desired outside dimensions. Place the backing aside.

. Lay the mat out in front of you faceup, as if it contained the print. Measure the mat from one side to the other to find the center. Mark it, and then draw a light pencil line vertically through the center of the mat.

. Measure the image area of the print from the left-hand side to the right-hand side. Say it measures 10 inches (25.4 cm). Add ½-inch (1.3 cm) onto this measurement for the borders, and ¼-inch (.64 cm) on each side of the impression.

. On the mat, measure and mark 5¼-inches (13.3 cm) from the center line on the left-hand side of the mat and 5¼-inches from the center to the right-hand side of the mat. The left-to-right dimension of the mat window now measures 10½-inches (26.7 cm).

. Measure the mat from one of the window lines on the side to the outside edge. Let's say it measures 3-inches (7.7 cm). From the top of the mat, measure down 3-inches, then draw a line lightly across the top. Your mat now has a 3-inch border on the sides and at the top.

. Measure the print once again, this time from the top of the image area to the bottom. Let's say this measurement is 8-inches (20.3 cm). Add ¾-inch (1.9 cm) to this figure. This allows for a border of ¼-inch (.64 cm) at the top of the impression, and ½-inch (1.3 cm) at the bottom.

7. From the top line on the mat, measure down 8¾-inches (22.2 cm). Mark and then draw the line to complete the mat window.

8. Before cutting out the mat, it is a good idea to run a strip of masking tape along the backside of your metal bar or yardstick. This will help keep it from slipping while the mat is being cut.

After the mat and backing have been cut to the desired outside size, the window dimensions are laid out on the mat board in very light pencil. The pencil lines shown here have been drawn dark to make them visible in the photograph.

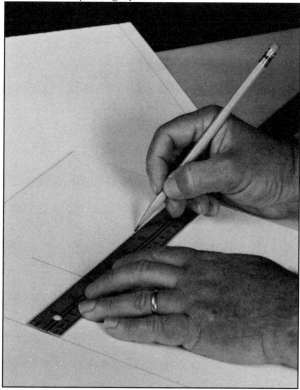

9. Cut out the mat window. Cut with the blade toward the inside of the window; if the knife should slip it will not cut into the mat. Lightly sand the outside edge of the mat window if desired.

10. Place the mat and backing face down and end to end. Make sure the top of the mat and not the bottom is butted against the backing.

11. Run a strip of dry linen tape between the mat and the backing. Line it up so that one half overlaps the mat, and the other half overlaps the backing. Draw a pencil line along one side of the tape. This will serve as a placement guide when the tape is wet and pressed into place. You may find it advantageous to join the mat and backing first with two or three one-inch strips of tape before the main hinge is applied. Wet the tape with a sponge or cloth. Line it up with the pencil line and apply it to mat and backing. Rub it down firmly with the heel of your hand.

12. Place the print in the center of the backing and fold the mat over. Align the print under the mat window. Place a weight on the print to keep it from slipping, then open the mat. Adhere the print to the backing with two one-inch (2.5 cm) strips of tape.

13. Erase pencil lines and finger marks.

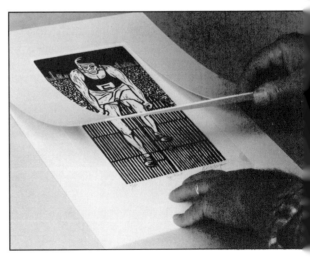

P 1 The board is cut with the knife ...de toward the inside of the mat window. ...bar used here is a strip of aluminum ...chased at a hardware store. It has slight-...ounded edges which allow the knife to ...e easily along the length of the bar. ...ause of the rounded edge, cutting a mat ...n a slight bevel is possible.

P 2 A strip of linen tape joins the mat ...n the backing. Before the strip is perma-...tly glued in place draw a line the length ...e backing so that the tape can be prop-...affixed. Note that the small linen strips ...ixed to the mat and backing before the ...n hinge is applied.

3 The print is positioned under the ...window, aligned, and then fixed to the ...ing with two small linen tabs.

FRAMES

Frames, like mats, should enhance and not detract from the print. Aluminum frames, available in a variety of sizes, colors, and finishes, are popular because of their simplicity and durability. Wood frames should not be too wide or elaborate.

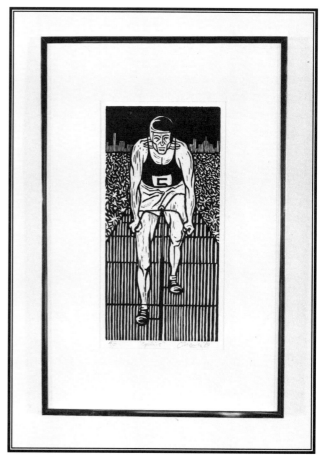

Simple frames of aluminum or wood construction are economical, practical, and effective.

GLOSSARY

Baren A flat, round device made from various substances; used to burnish woodblocks.

Bevel The slanted portion of a woodcut tool between the shank and the tip.

Black ground A woodblock covered with a tin coat of black printing or drawing ink.

Bleeding A stain that appears adjacent to a printed area; usually caused by exceedingly thin or oily ink.

Brayer A small roller with a single handle.

Buffing wheel A cotton disk used to polish metal. It is attached to a grinding or polishing machine. It can also be attached to an electric drill.

Burin A steel tool with a lozenge-shaped tip used for engraving on wood blocks or metal plates. Also called a graver.

Burnish To rub.

Burnisher A smooth steel tool used in intaglio printing for rubbing on metal plates; not to be confused with a burnishing tool such as a spoon used for rubbing woodcuts.

Chisel A flat, straight-edge carving tool.

Conté A non-oily, charcoal-like drawing material.

Cross-cut handsaw A saw designed to cut boards across the grain of the wood.

Crosshatch Close-set intersecting lines used in drawing, engraving, and cutting to create varying tonalities.

Dabber A type of pad, usually made of cotton batting covered with smooth leather. Dabbers are used to cover woodblocks or metal plates with ink.

Edition A series of numbered prints.

End Grain The end, or face, of a tree or log that contains the rings.

Figure-ground relationship The design relationship between an object and its background.

Gesso A plaster and glue mixture used to coat canvas, masonite, or wood.

Gouge A scooped woodcutting or carving tool.

Graver See *burin*.

Ground A coating applied to a flat surface.

Hacksaw A fine-tooth saw used primarily on metal, but also used for cutting out small sections of wood.

Haloing A band of light adjacent to or surrounding a printed area.

Impression A printed image.

Ink knife See *putty knife*.

Ink glass A sheet of glass used to roll out ink.

Intaglio Italian for "below" or "beneath the surface"; involves printing from a metal plate in which recessed lines or cells have been filled with ink. The ink is transferred to paper under pressure from an etching press.

Linocut A relief print similar to woodcut but produced from linoleum.

Maniére criblée French for "dotted manner."

Maniére noire French for "black manner."

Mask A type of stencil used to cover rolled up portions of a woodblock before printing.
Model To give the illusion of volume and three dimensions.
Modeling paste A heavy acrylic-like substance used to build up relief surfaces.

Off register An impression in which the colors have been printed out of alignment, or a single color block on which the paper has slipped, causing a double image.

Palette knife A flexible knife with a wooden handle used for mixing or applying oil paints.
Plank grain The side of a log or board along which the direction of the grain runs.
Plate A term usually applied to a sheet of metal, but also used to describe any thin material used as a base for a relief print.
Plug A minute block of wood used to replace a damaged area within a woodblock.
Proof A test print.
Pull To print; derived from the act of removing a completed impression from a block.
Putty knife A flat sheet of metal fixed to a handle. Used to apply putty or to scrape. When used to spread or scrape ink, it is called an ink knife.

Raked Having a backward slope.
Registration The system used for aligning colors when printing from separate blocks.
Relief A raised surface.

Reverse image When a woodcut is printed, the objects in the carving show up in the impression opposite to the woodblock, as if seen in a mirror.
Rouge A red-colored polishing compound.
Rouge wheel A buffing wheel that uses rouge polishing compound.

Shape A flat enclosed area.
Slips Minute sharpening stones of various shapes used to remove burrs from the inside cutting edges of woodcut tools.
Stamp prints Woodcuts printed by placing a block face down and transferring the ink by pressing or pounding the back of the block.
Strop A leather strap or belt used to sharpen straight razors or to remove burrs from the inside cutting edge of a gouge.
Sweep The depth of a carving or sculpture tool's scoop.

Tone See *value*.

Value Lightness or darkness of a color, or a shade between white and black.
Visual texture An active surface pattern that can be seen but not felt.
Volume In two-dimensional art, a three-dimensional illusion of fullness or roundness.

White glue A glue made from milk; used for gluing wood, fabrics, or paper.

BIBLIOGRAPHY

GENERAL PRINTMAKING TECHNIQUES

Griffiths, Anthony. *Prints and Printmaking: An Introduction to the History and Techniques*. New York: Alfred A. Knopf, 1980.

Peterdi, Gabor. *Printmaking Methods Old and New*. New York: Macmillan, 1971.

Ross, John, and Clare Romano. *The Complete Printmaker*. New York: The Free Press, 1972.

Saff, Donald, and Deli Sacilotto. *Printmaking*. New York: Holt, Rinehart and Winston, 1978.

WOODCUT, WOOD ENGRAVING, AND LINOCUT

Biggs, John R. *Woodcuts*. London: Blanford Press, 1958.

Farleigh, John. *Engraving on Wood*. Leicester: Dryad Press, 1954.

Kafka, Francis J. *Linoleum Block Printing*. New York: Taplinger Publishing Co., 1958.

Mueller, Hans A. *Woodcuts and Wood Engravings and How I Make Them*. New York: Pynson Printers, 1939.

O'Connor, John. *The Technique of Wood Engraving*. London: B.T. Batsford, Ltd., 1971.

Rothenstein, Michael. *Linocuts and Woodcuts: A Complete Block Printing Handbook*. New York: Watson-Guptill, 1964.

Rumpel, Henrich. *Wood Engraving*. Geneva: Bonvent, 1972.

Ward, Lynd. *Vertigo*. New York: Random House, 1937.

GENERAL RELIEF PRINTING

Daniels, Harvey. *Printmaking*. New York: Viking Press, 1973.

Bodor, John J. *Rubbings and Textures: A Graphic Technique*. New York: Reinhold, 1968.

Green, Peter. *Introducing Surface Printing*. New York: Watson-Guptill, 1967.

Green, Peter. *New Creative Printmaking*. New York: Watson-Guptill, 1967.

Kent, Cyril, and Mary Cooper. *Simple Printmaking*. New York: Watson-Guptill, 1966.

Ross, John, and Clare Romano. *The Complete Relief Print*. New York: The Free Press, 1974.

Rothenstein, Michael. *Relief Printing*. New York: Watson-Guptill, 1970.

Smith, Charles. *Experiments in Relief Printing*. Charlottesville: University of Virginia, 1954.

SUPPLIERS

Daniel Smith Inc.
4130 1st Avenue South, Seattle, WA 98134-2302
(800) 426-6740 (catalog, printmaking, and art supplies)

Dick Blick Company
P.O. Box 1267 Galesburg, IL 61401
(800) 447-8192 (catalog, printmaking, and art supplies)

Graphic Chemical and Ink Company
728 North Yale Avenue Villa Park, IL 60181
(708) 832-6004 (catalog, printmaking papers, and inks)

Rembrandt Graphic Arts Company Inc.
P.O. Box 130 Rosemont, NJ 08556
(609) 397-0068 (catalog, printmaking, and art supplies)

Sam Flax Inc.
25 East 28th Street New York, NY 10016
(212) 620-3000 (Outlets in Chicago, Los Angeles, San Francisco, and Sacramento)
(catalog, printmaking, and art supplies)

Woodcraft
210 Wood County Industrial Park Rd.
P.O. Box 1686 Parkersburg, West Virginia 26102-168
(800) 225-1153 (woodworking tools)

6986